IDIOT'S GUIDES

AS EASY AS IT GETS!

W9-BNB-668

Drawing Manga

DISCARD

by 9colorstudio

ALPHA

A member of Penguin Group (USA) Inc.

ALPHA BOOKS

Published by Penguin Group (USA) Inc.

Penguin Group (USA) Inc., 375 Hudson Street, New York, New York 10014, USA • Penguin Group (Canada), 90 Eglinton Avenue East, Suite 700, Toronto, Ontario M4P 2Y3, Canada (a division of Pearson Penguin Canada Inc.) • Penguin Books Ltd., 80 Strand, London WC2R 0RL, England • Penguin Ireland, 25 St. Stephen's Green, Dublin 2, Ireland (a division of Penguin Books Ltd.) • Penguin Group (Australia), 250 Camberwell Road, Camberwell, Victoria 3124, Australia (a division of Pearson Australia Group Pty. Ltd.) • Penguin Books India Pvt. Ltd., 11 Community Centre, Panchsheel Park, New Delhi—110 017, India • Penguin Group (NZ), 67 Apollo Drive, Rosedale, North Shore, Auckland 1311, New Zealand (a division of Pearson New Zealand Ltd.) • Penguin Books (South Africa) (Pty.) Ltd., 24 Sturdee Avenue, Rosebank, Johannesburg 2196, South Africa • Penguin Books Ltd., Registered Offices: 80 Strand, London WC2R 0RL, England

Copyright © 2013 by Penguin Group (USA) Inc.

All rights reserved. No part of this book may be reproduced, scanned, or distributed in any printed or electronic form without permission. Please do not participate in or encourage piracy of copyrighted materials in violation of the author's rights. Purchase only authorized editions. No patent liability is assumed with respect to the use of the information contained herein. Although every precaution has been taken in the preparation of this book, the publisher and author assume no responsibility for errors or omissions. Neither is any liability assumed for damages resulting from the use of information contained herein. For information, address Alpha Books, 800 East 96th Street, Indianapolis, IN 46240.

IDIOT'S GUIDES and Design are trademarks of Penguin Group (USA) Inc.

International Standard Book Number: 978-1-61564-415-5
Library of Congress Catalog Card Number: 2013935159

15 14 13 8 7 6 5 4 3 2 1

Interpretation of the printing code: The rightmost number of the first series of numbers is the year of the book's printing; the rightmost number of the second series of numbers is the number of the book's printing. For example, a printing code of 13-1 shows that the first printing occurred in 2013.

Note: This publication contains the opinions and ideas of its author. It is intended to provide helpful and informative material on the subject matter covered. It is sold with the understanding that the author and publisher are not engaged in rendering professional services in the book. If the reader requires personal assistance or advice, a competent professional should be consulted. The author and publisher specifically disclaim any responsibility for any liability, loss, or risk, personal or otherwise, which is incurred as a consequence, directly or indirectly, of the use and application of any of the contents of this book.

Most Alpha books are available at special quantity discounts for bulk purchases for sales promotions, premiums, fund-raising, or educational use. Special books, or book excerpts, can also be created to fit specific needs. For details, write: Special Markets, Alpha Books, 375 Hudson Street, New York, NY 10014.

Trademarks: All terms mentioned in this book that are known to be or are suspected of being trademarks or service marks have been appropriately capitalized. Alpha Books and Penguin Group (USA) Inc. cannot attest to the accuracy of this information. Use of a term in this book should not be regarded as affecting the validity of any trademark or service mark.

Publisher: Mike Sanders

Executive Managing Editor: Billy Fields

Acquisitions Editor: Brook Farling

Development Editor: Megan Douglass

Production Editor: Jana M. Stefanciosa

Book Designer/Layout: William Thomas

Proofreader: Jeanne Clark

ALWAYS LEARNING PEARSON

Contents

R0440154801

DISCARD

OCT 2013

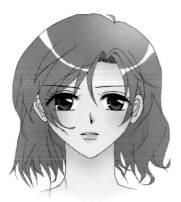

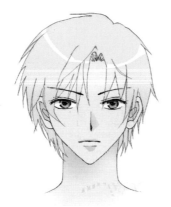

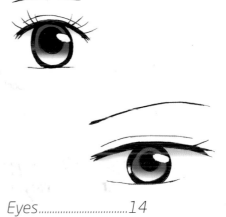

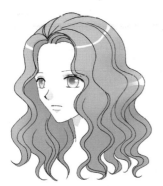

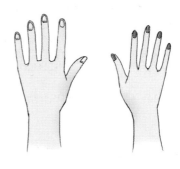

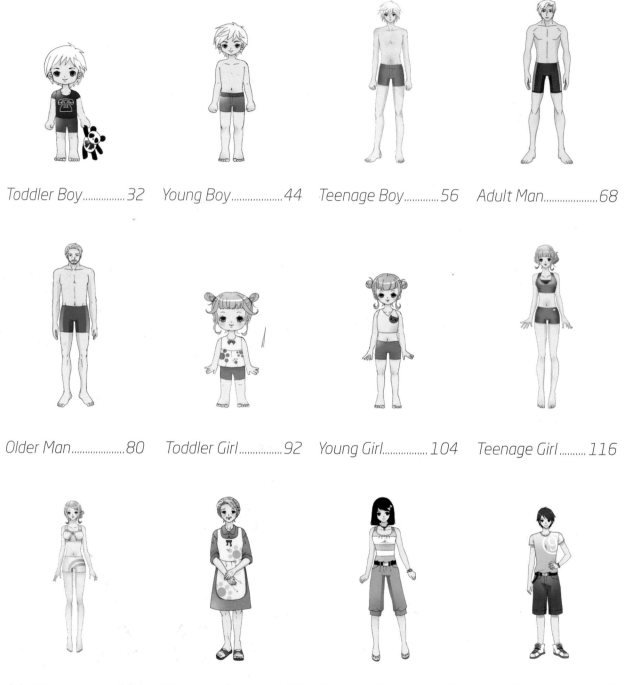

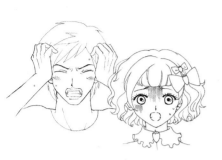

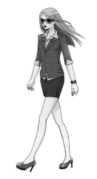

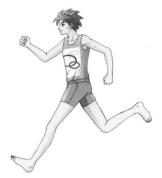

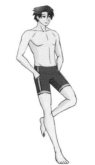

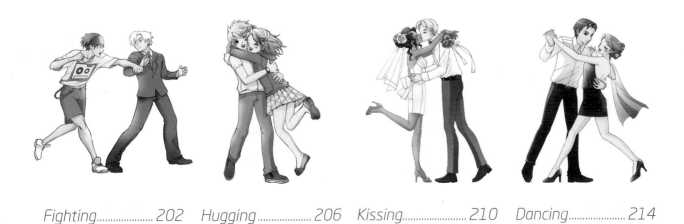

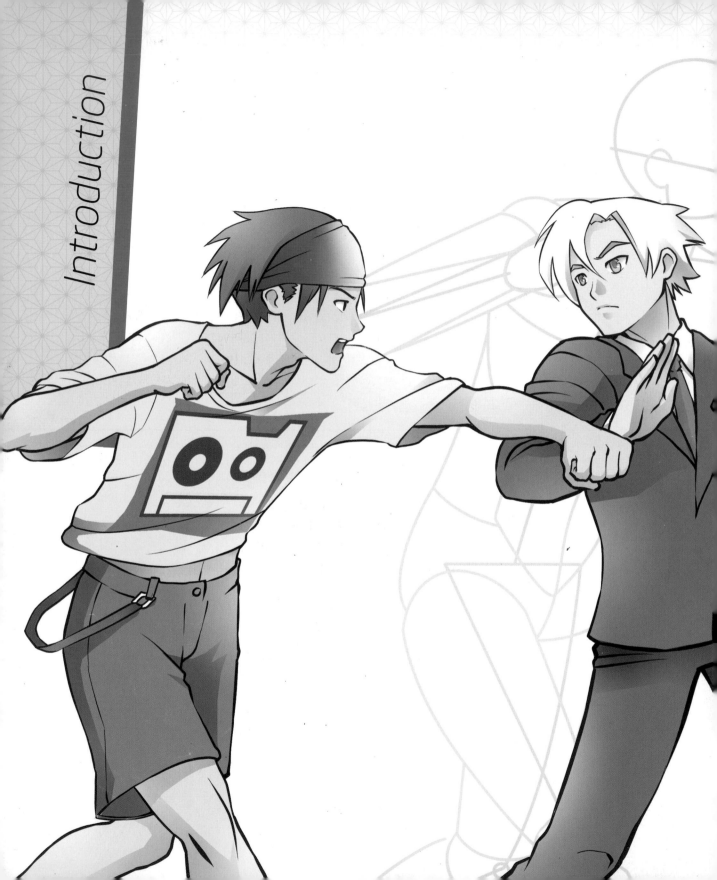

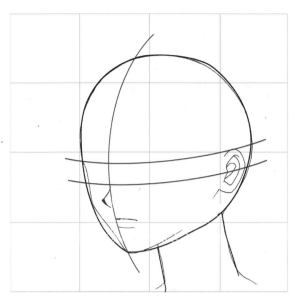

Refine the face shape. Draw a delicate jaw, a small nose, and an ear on the right side.

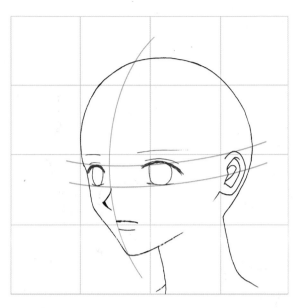

Draw the eyes and eyebrows. The eye on the left should be narrower than the right.

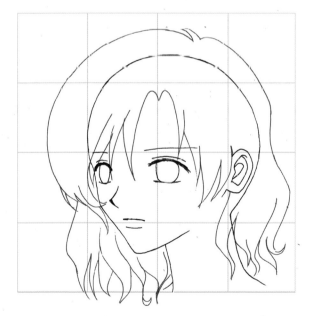

Draw the basic shape of the hair. Hair should be drawn slightly bigger than the head.

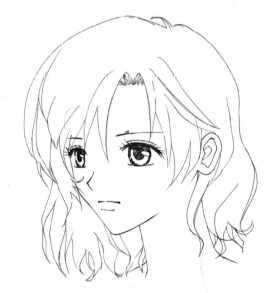

Refine the hair and eyes. Adding strokes for texture will make the hair more realistic.

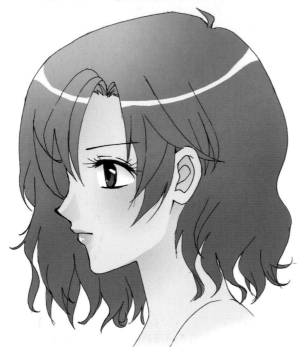

The side view requires different shapes, because it only shows half the face.

Side View

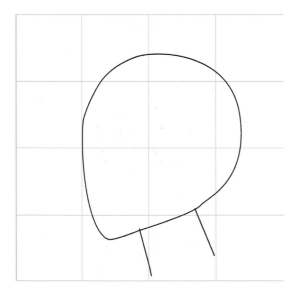

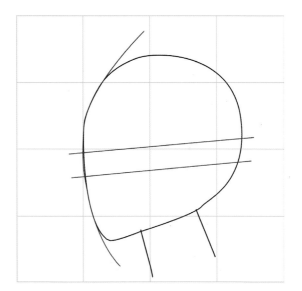

Draw an oval as the basic face shape. The head is turned, so the left (face) should be flattened and the right (skull) should be round. Add lines for a neck.

Place the nose and mouth guideline at the left side. The guidelines for the eye should tilt down to the left.

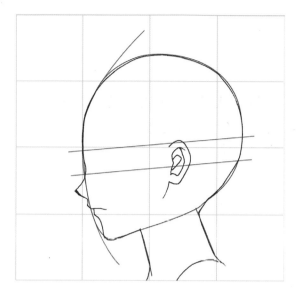

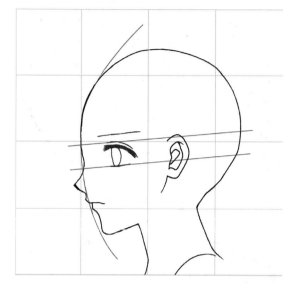

Refine the face shape. Draw a small nose beneath the eye guidelines. Add a mouth and delicate jaw. The ear should be drawn at the middle of the eye guidelines.

Now draw the eye and eyebrow. The eye should be located closer to the left side.

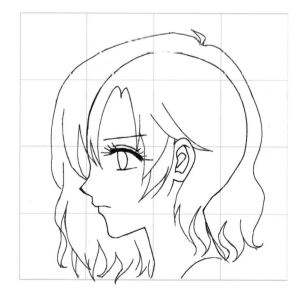

Draw the basic shape of the hair. Hair should be drawn slightly bigger than the head.

Refine the hair and eye. Adding strokes for texture will make the hair more realistic.

Male Faces

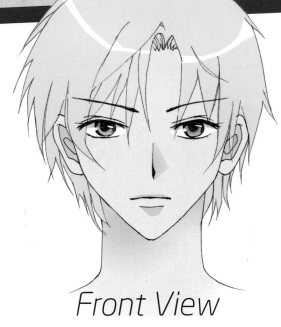

Front View

Compared to a female, the male has:

> A longer face

> Smaller eyes

> Longer nose

> More defined jaw

> Thicker neck

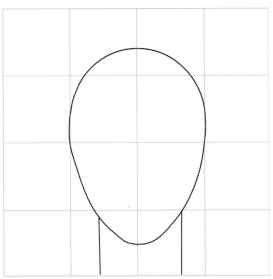

Draw an oval as the basic face shape. Remember to make it slightly longer than a female's face. Add lines for a neck.

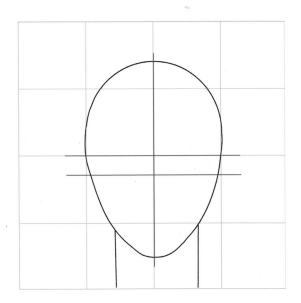

Draw guidelines where the eyes, nose, and ears will be located. A male has smaller eyes, so the horizontal lines should be closer together.

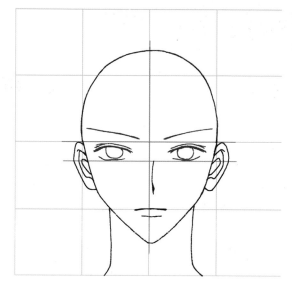

Refine the face shape, making it more pointed at the chin and defining the strong jaw. Add the ears, nose, and mouth.

Draw the eyes and eyebrows. Draw the eyebrows slightly up at the end for a bold, masculine look.

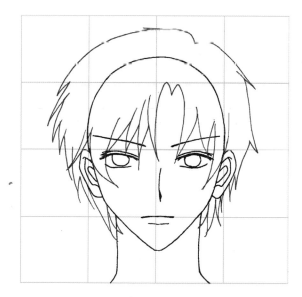

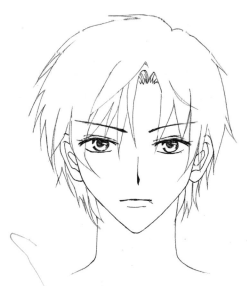

Draw the basic shape of the hair. Hair should be drawn slightly bigger than the head.

Refine the hair and eyes. Adding strokes for texture will make the hair more realistic.

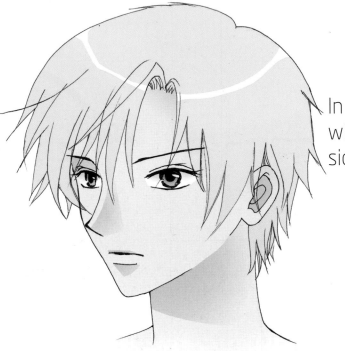

In three-quarter view, the face will look slightly narrower on one side.

Three-Quarter View

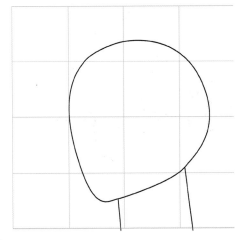

Draw an oval as the basic face shape. The head is slightly turned, so it should be flattened on the left and rounder on the right. Add lines for a neck.

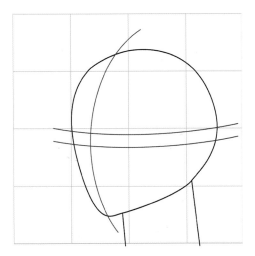

Draw guidelines where the eyes, nose, and ears will be located. The vertical line should be angled toward the left side of the face.

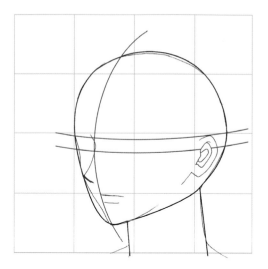

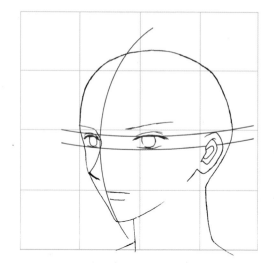

Refine the face shape. Draw a strong jaw, a nose, and an ear on the right side. The nose should be longer than for a female, and has a bridge.

Draw the eyes and eyebrows. The eye on the left should be narrower than the right.

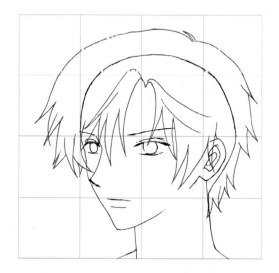

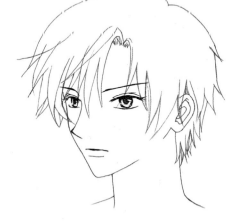

Draw the basic shape of the hair. Hair should be drawn slightly bigger than the head.

Refine the hair and eyes. Adding strokes for texture will make the hair more realistic.

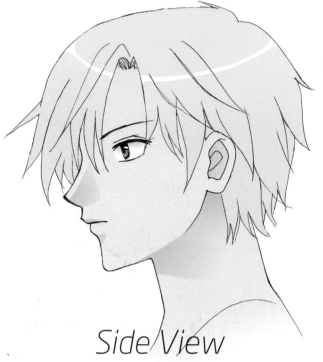

The male side view will differ from the female by including a longer nose bridge, longer face shape, bigger neck, sharper jaw, and smaller eye.

Side View

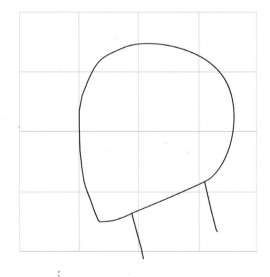

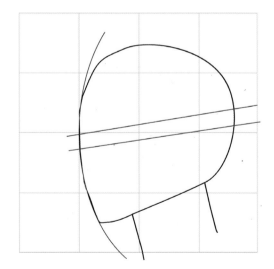

Draw an oval as the basic face shape. The head is turned, so the left (face) should be flattened and the right (skull) should be round. Add lines for a neck. Don't forget that the male has a longer face and bigger neck compared to the female.

Place the nose and mouth guideline at the left side. The guidelines for the eye should tilt down to the left. Remember that the eye guidelines should be closer together, because the male has a smaller eye.

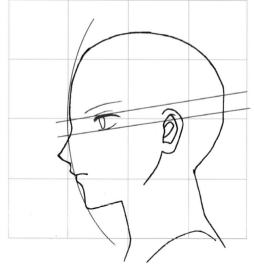

Refine the face shape. Draw a nose with a longer bridge beneath the eye guidelines. Add a mouth and a sharper jaw. The top of the ear should be drawn at the middle of the eye guidelines.

Now draw the eye and eyebrow. The eye should be located closer to the left side. For the male, tilt the eyebrow up a bit at the end.

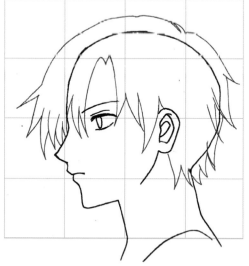

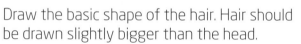

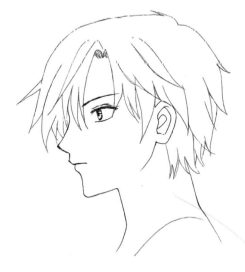

Draw the basic shape of the hair. Hair should be drawn slightly bigger than the head.

Refine the hair and eye. Adding strokes for texture will make the hair more realistic.

Eyes

Eyes show your character's emotions.

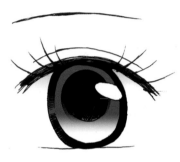

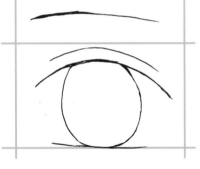

Draw the basic shapes of an eyeball, eyelid, and eyebrow with single lines.

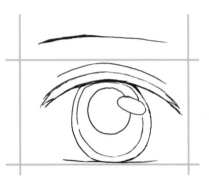

Make the eyelid thicker and add a pupil and a small highlight reflection near the pupil.

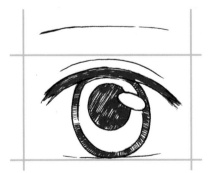

Fill the shapes, but avoid the highlight area.

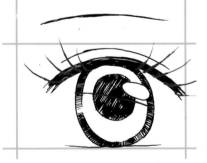

Add some eyelashes on the right and left, and make a single line for the shadow of the eye.

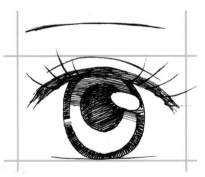

Fill the shadow area gradually, shading from black to white.

Placement

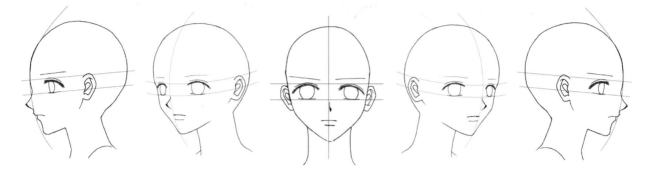

Drawing guidelines will help with eye placement. On the face, you want the first guideline to be at the halfway point between the top of the head and the chin. The second guideline should be at the top of the jaw line. This will help you draw the bottom of the eye.

Eyelashes

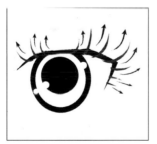

Draw the eyelashes curved to follow the shape of the eyes.

Drawing the lashes straight up will make them look stiff, like straw.

Learning to draw a wide variety of eyes is an easy way to differentiate characters. If you vary the eyes, you can use the same face shape and hair and still have two different characters.

The key is to change the shapes: A slight tilt up at the corner makes the character look bold; an eye line looking down at the floor will make the character look timid.

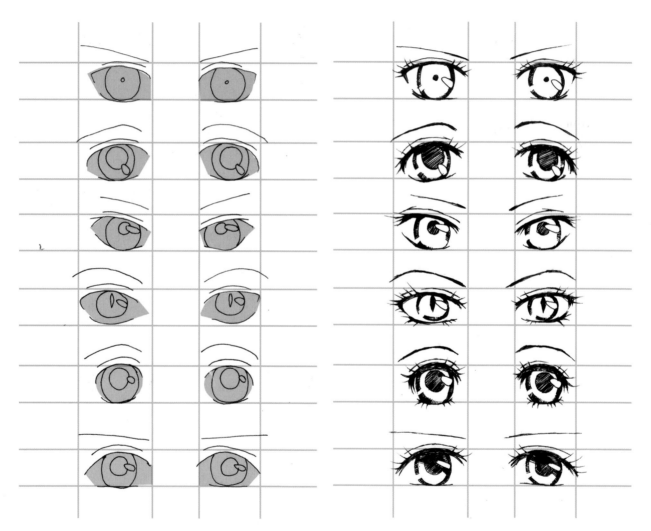

Draw the basic strokes. To vary the eyes, make some changes to the corner of the eye, the pupil size, and the eyebrow shape.

Refine with some shading; fill the eyelids and pupils with black.

Here are some examples showing the same female face with different eyes. Notice how each face looks like a different person.

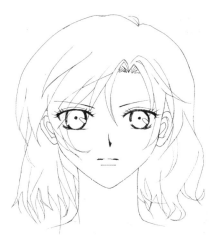

Upturned eyes:
bold and brave girl

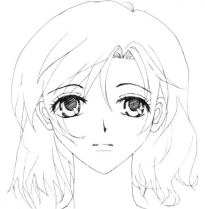

Tilted down: timid girl

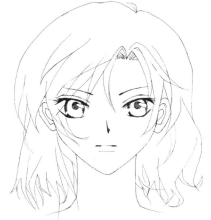

Upraised eyes and eyebrows:
emotional, resentful girl

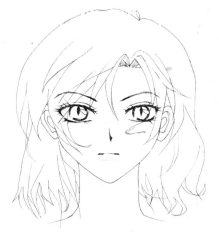

Narrow pupil: wild girl

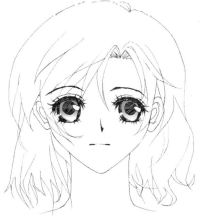

Big eyes: cute, innocent girl

Curved upper eyelid, straight
lower line: girl next door

There are a few differences for male eyes compared to female eyes, including a smaller eyeball, longer eyelid, and tilted eyebrow.

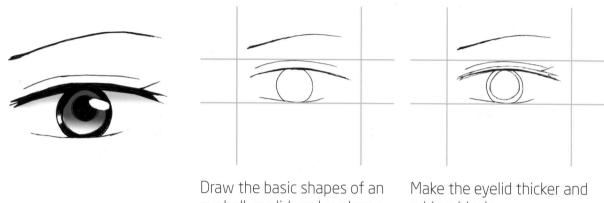

Draw the basic shapes of an eyeball, eyelid, and eyebrow with single lines.

Make the eyelid thicker and add an iris ring.

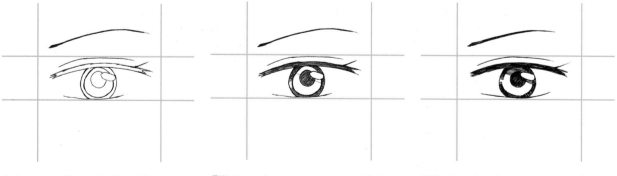

Add a pupil and a highlight near the pupil.

Fill the shapes, but avoid the highlight area.

Fill the shadow area gradually, shading from black to white.

Placement

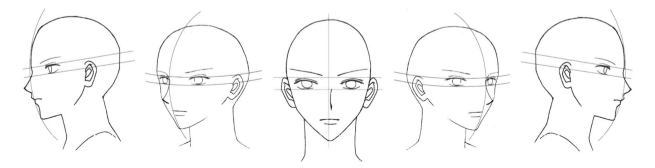

Drawing guidelines will help with placement of the eyes, ears, and nose. The top guideline should be about halfway between the top of the head and the chin. The second guideline should be at the top of the jawbone, which is also the center point for the ears.

Eyebrow

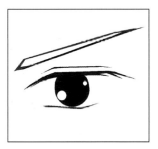

Start with a diagonal line, angled up from the inside corner. Add a line above, angling down to meet at the outside corner. Connect the lines with a point at the inside corner.

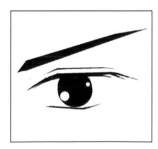

Fill in the eyebrow.

As with female eyes, male eyes are easy to vary. A little tilt up at the corner makes the character look cool. An eye line that is tilted down makes the character look apathetic.

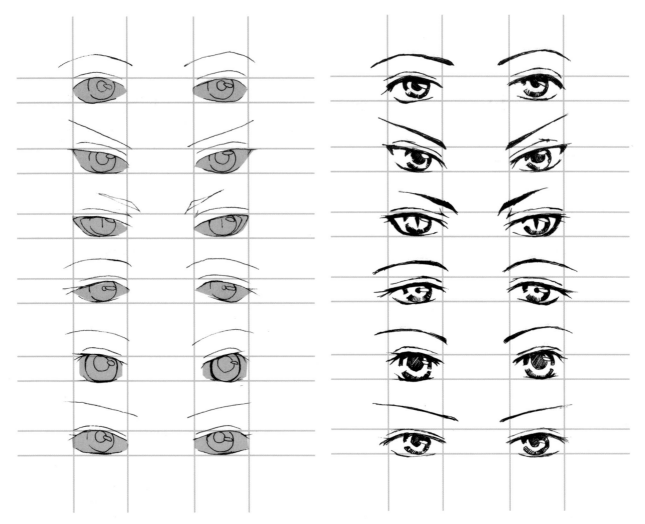

Draw the basic strokes. To vary the eyes, make some changes to the corner of the eye, the pupil size, and the eyebrow shape.

Refine the line with some shading; fill the eyelids and pupils with black.

Here are some examples showing the same male face with different eyes. Again, each face looks like a different person.

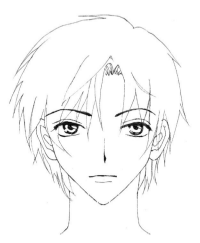

Almond-shape eyes and curvy eyebrows: boy next door

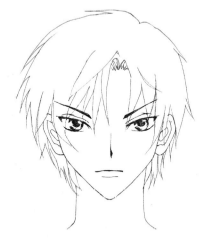

Tilted up eyes and eyebrows: hot-tempered boy

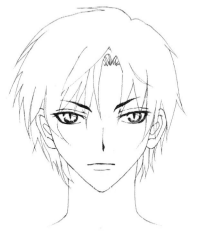

Upraised eyebrow, narrow pupil: wild boy

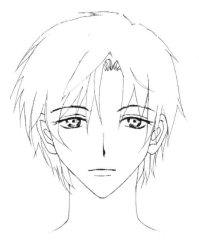

Tilted down eyes and eyebrows: apathetic, loner boy

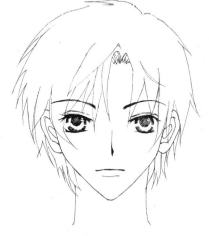

Big eyes, short eye line: cute, energetic boy

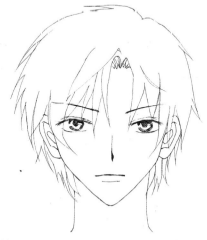

Upraised eyebrows, tilted up almond-shape eyes: cool boy

Female Hair

Spiral Curly Hair

Spiral curly hair is one of the biggest trends in manga. The curl gives a sweet and sensual appearance to the character.

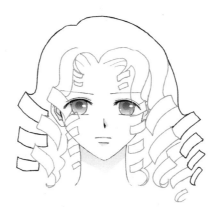

Draw a basic shape for hair placement. Hair should be about ¼ larger than the head. Then draw the first strokes, ending with a simple cylinder shape.

Add more cylinder shapes around the face, and some lines to connect them to the hair root.

Draw the connecting lines between the cylinder shapes, and the spiral curly hair for your character is done!

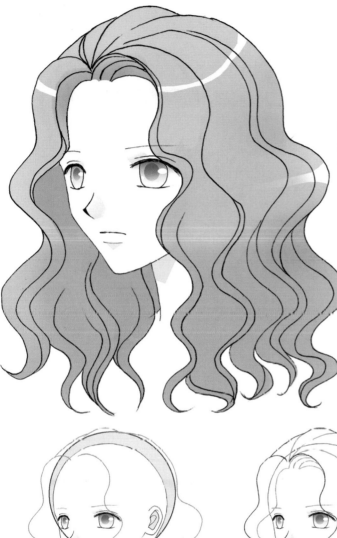

Wavy Hair

One of the classic hair styles for female characters is wavy hair. This hair gives the character a feminine and natural touch.

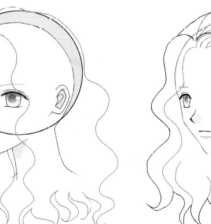

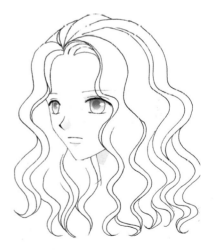

Draw a basic shape for hair placement. Hair should be about ¼ larger than the head. Then draw long, wavy strokes from the top of the head to the length you desire.

Continue adding wavy strokes.

Add wavy strokes close to previous strokes to create texture.

Straight Hair

Straight hair with bangs looks like the classic Japanese girl.

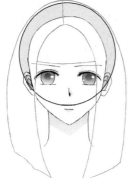

Draw a basic shape for hair placement. Hair should be about 1/4 larger than the head. Add some straight strokes from the top of the head to the hair edge. Add a horizontal line for the bangs.

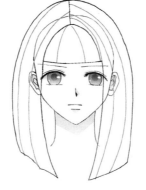

Continue adding straight lines.

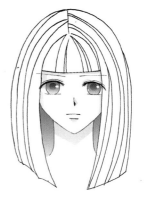

Fill in more straight lines to add texture.

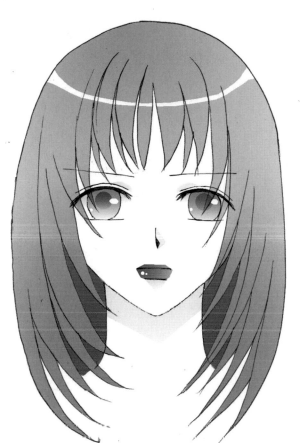

Layered Hair

One of the latest style trends is layered hair.
Use this style for a fresh, modern look.

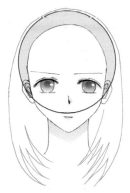

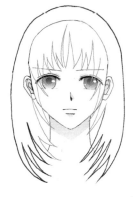

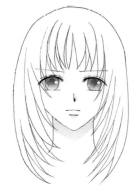

Draw a basic shape for hair placement. Hair should be about $\frac{1}{4}$ larger than the head. Draw strokes from the top of the head to the hair edge, and make some sharp points at the end of the hair.

Continue adding sharp points at the hair edge, including the bangs.

Finish by adding some lines throughout the hair for texture.

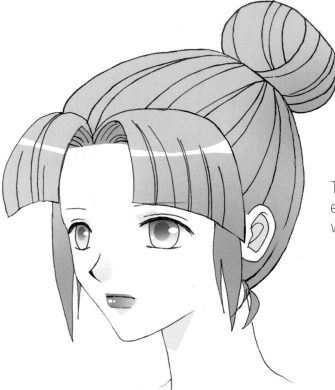

A Bun

This simple up-do will give your character an elegant, party-ready look when combined with a cocktail dress and stilettos.

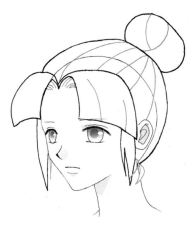

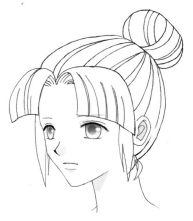

Draw a basic shape for hair placement. Hair should be about ¼ larger than the head. Add some bangs up front and a circle for the bun.

Refine the look by adding some lines on the head and the bun. Remember, the strokes should follow the circular shapes of the head and bun.

Add more lines for texture.

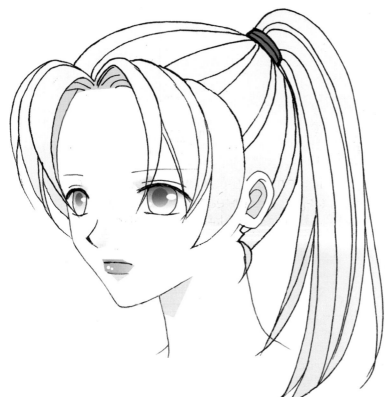

A Ponytail

Is your character a cheerleader or a basketball player? A ponytail will give her an energetic look.

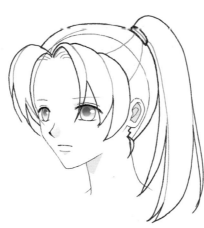

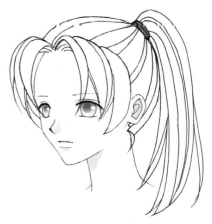

Draw a basic shape for hair placement. Hair should be about ¼ larger than the head. Add some bangs parting in the middle, and draw the ponytail with pointy hair edges.

Draw more strokes, following the head shape and the ponytail.

Refine by adding more lines for texture.

Male Hair

Wavy Hair

Wavy hair gives him a more sensual look.

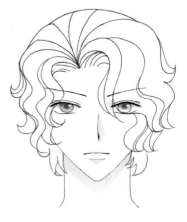

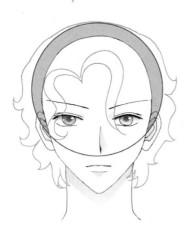

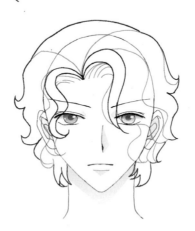

Draw a basic shape for hair placement. Hair should be about ¼ larger than the head. Add a combination of wavy strokes and curly edges.

Refine by adding more wavy strokes and curly edges.

To make his hair more natural looking, add more wavy lines for texture.

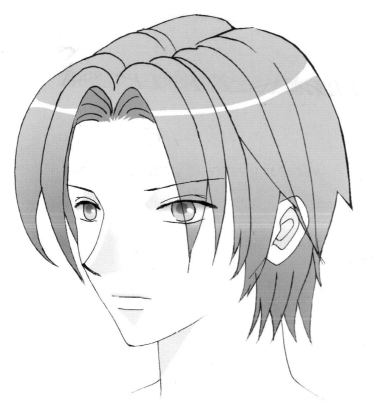

Straight Hair

Do you have a cool, confident character with a mysterious aura? Try straight hair with longer bangs.

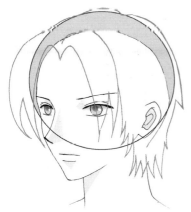

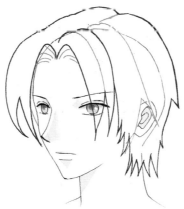

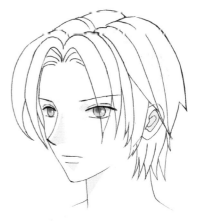

Draw a basic shape for hair placement. Hair should be about ¼ larger than the head. Add chunky bangs that part in the middle. Draw the hair strokes with pointy edges.

Fill in the hairline with short strokes. Add more pointy edges.

Refine the hair with more straight strokes for texture.

Hands

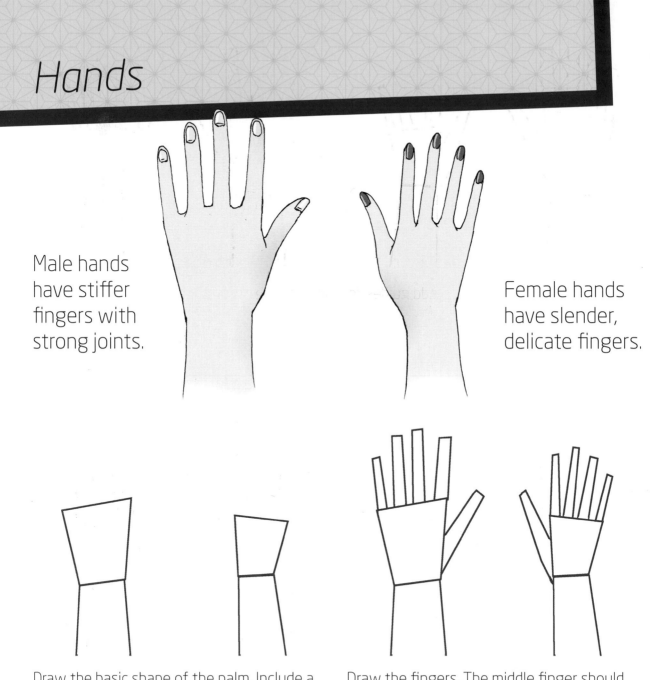

Male hands have stiffer fingers with strong joints.

Female hands have slender, delicate fingers.

Draw the basic shape of the palm. Include a wrist line, and continue with the arm.

Draw the fingers. The middle finger should be the tallest, and the pinky finger should be the shortest. The thumb should be located on the right side for the left hand, and on the left side for the right hand.

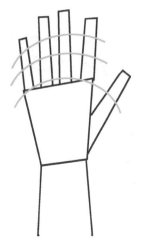 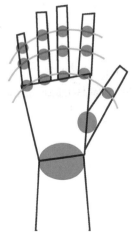

Add guides for joint placement.

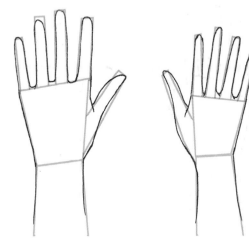

Refine the hand with smoother, more rounded shapes.

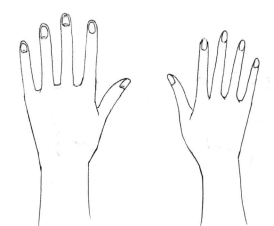

Add fingernails.

Toddler Boy

Front View

Draw a stick figure with a big head and short body. It should have small legs and arms. Draw circles where the joints are located.

To make a male toddler different from the female, give him shorter hair, thicker eyebrows, and no eyelashes.

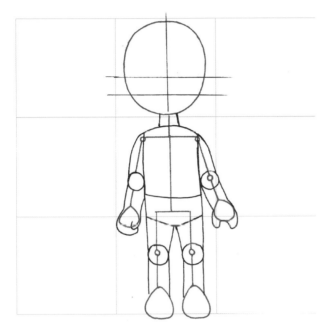

Draw a basic outline for the body, with guidelines for the eye placement.

Refine the body, leg, and head shapes. Add ears.

A toddler girl's face is round and lacks a defined chin.

A toddler boy's face is a little longer and the jaw is more square.

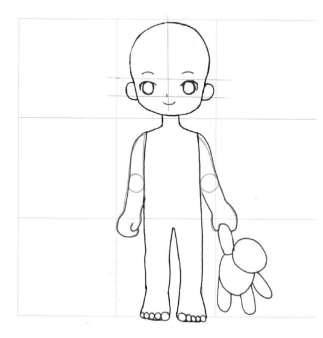

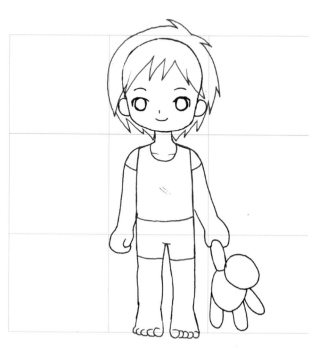

Refine the arms, and add eyes, a nose, and a mouth. Draw the toes. Add a basic teddy bear outline.

Refine the toes. Start drawing the hair, which should be bigger than the head. Draw a basic outline of the clothes.

Now draw clothes for your little boy.

Draw a short-sleeve, collared shirt and shorts.

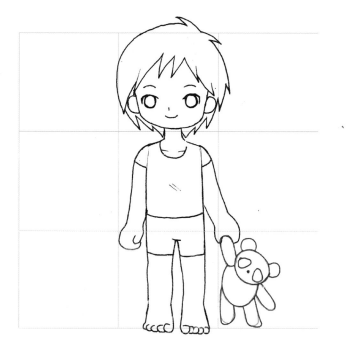

Add some details to the teddy bear.

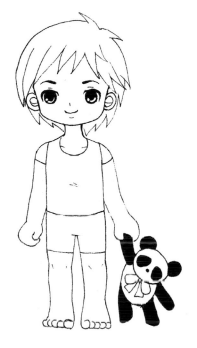

Add a few small details to the boy's eyes and hair. Color the bear and give it a bow.

Add a tie, socks, and shoes.

Isn't he cute?

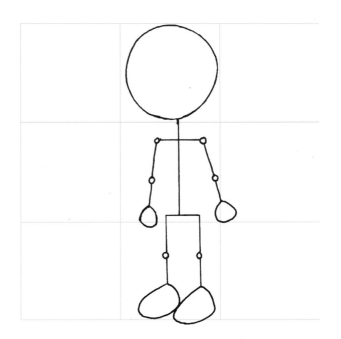

Draw a stick figure, rotated a bit toward the side. Draw circles where the joints are located.

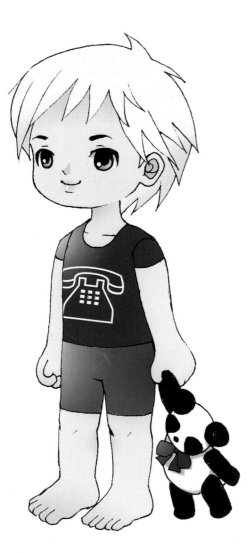

Three-Quarter View

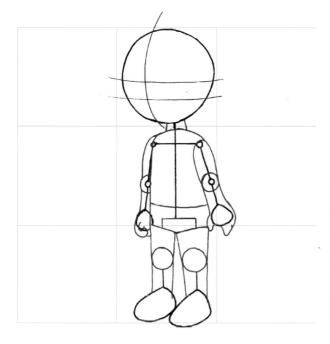

Draw a basic outline for the body, with guidelines for the eye placement.

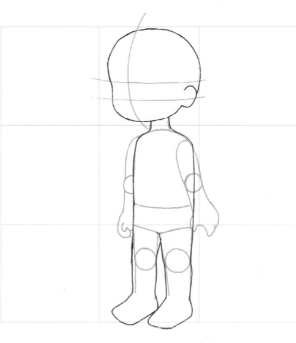

Refine the body, leg, and head shapes. Add ears.

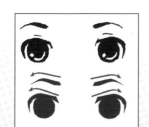

A toddler boy's eyes will have heavier eyelids and larger irises. The eyes curve up at the outer corners.

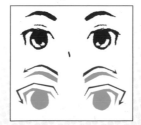

A young boy's eyes have thick eyebrows and slightly smaller irises and turn up at the outer corners.

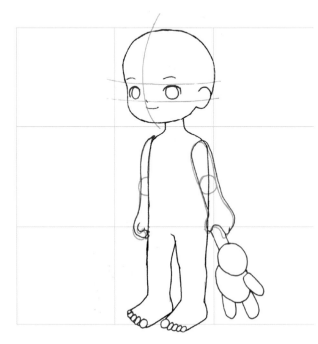

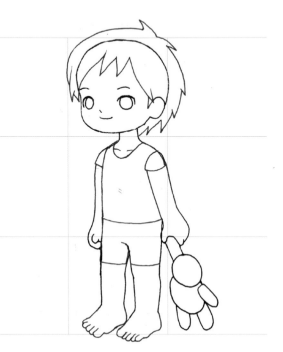

Refine the arms, and add a nose, a mouth, and eyes. For the ¾ view, the eye nearest the reader will look bigger. Draw toes. Add a basic teddy bear outline.

Refine the toes. Start drawing the hair, which should be bigger than the head. Draw a basic outline of the clothes.

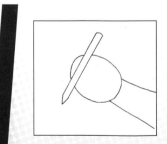

Draw the outline of a pencil. Then draw a circle for the back of the hand, and a basic arm. The hand is behind the pencil.

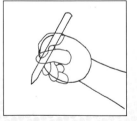

The thumb curves over the pencil. The tip of the first finger tucks under the thumb. The other fingers curl into the palm.

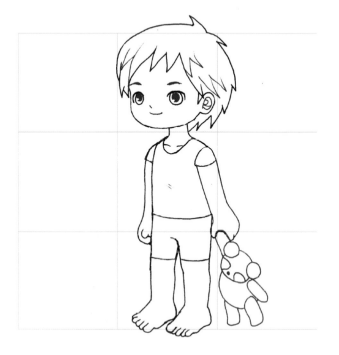

Add some details to the eyes, ear, hair, and teddy bear.

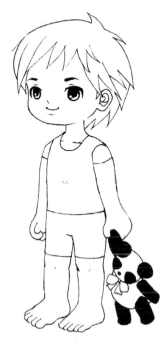

Add a few small details on the boy and bear.

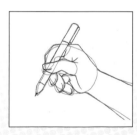

Smooth the lines and add details to the pencil. Add a thumbnail.

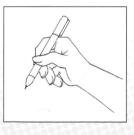

Here's a view of a hand holding a pencil.

Side View

Draw a stick figure, rotated for a side view. Draw circles where the joints are located.

Draw a basic outline for the body, with guide-lines for the eye placement.

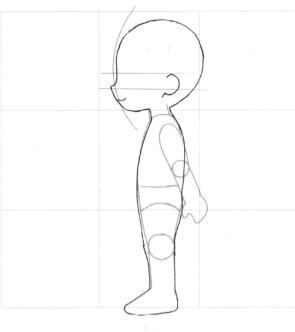

Refine the body, leg, and head shapes. The ear should be fully visible. Draw a very tiny nose.

A young boy has a longer face with a slightly ta-pered chin.

A toddler has a round face with chubby cheeks and no chin.

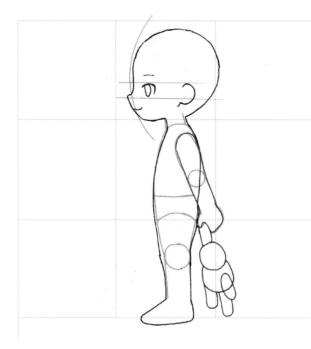

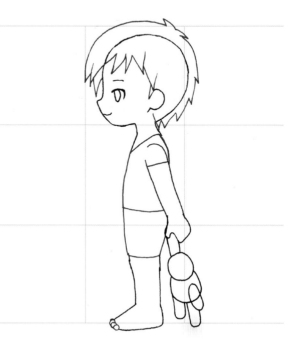

Refine the arms and face. Only one eye is visible. Add a basic teddy bear outline.

Start drawing the hair, which should be bigger than the head. Draw a basic outline of the clothes. Add toes.

Draw the outline of a pencil. Then draw a circle for the back of the hand, and a basic arm.

Draw the fingers. The thumb is not clearly seen from this view.

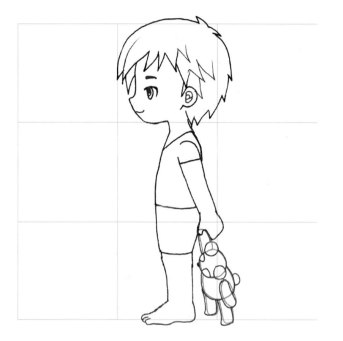

Add some details to the eyes, ear, and hair. Refine the toes and teddy bear.

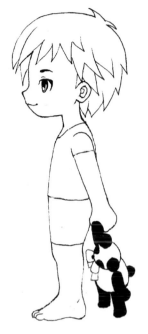

Add a few small details on the boy and bear.

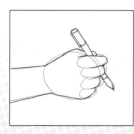

Smooth the lines and add details to the pencil.

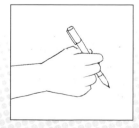

Here's how the back of a hand should look when holding a pencil.

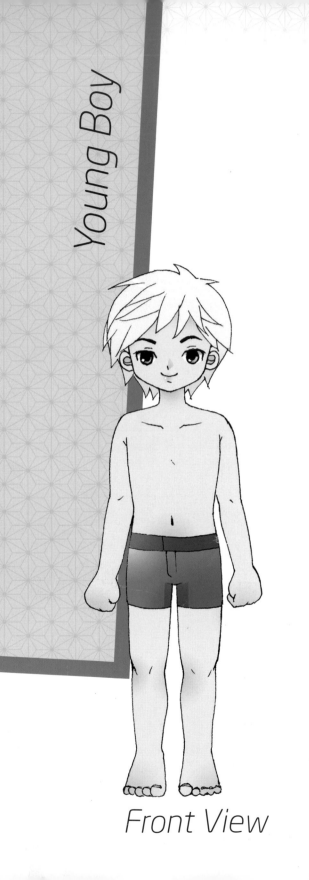

Young Boy

Front View

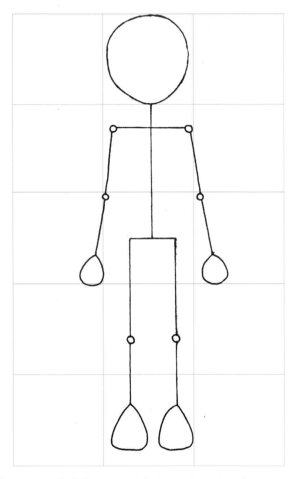

Draw a stick figure with broader shoulders and a taller body. Arms and legs are also longer. Draw circles where the joints should be.

At this age, a boy's muscles start to grow and he will have a bigger neck, broader shoulders, and stronger arms and legs.

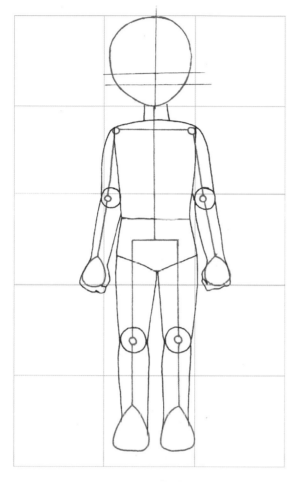

Draw a basic outline for the body, with guide-lines for the eye placement.

Refine the body, leg, and head shapes. Remember to make the legs a bit more muscular. Draw ears.

A toddler has a round face with chubby cheeks and no chin.

A young boy has a longer face with a slightly tapered chin.

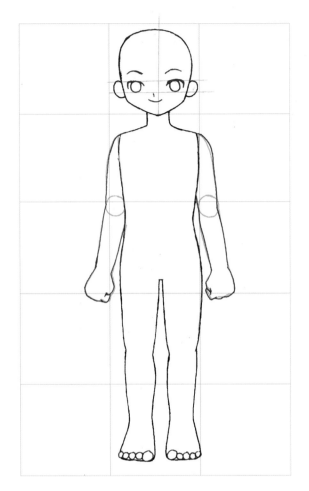

Refine the arms, and add eyes, a nose, and a mouth. Draw the toes.

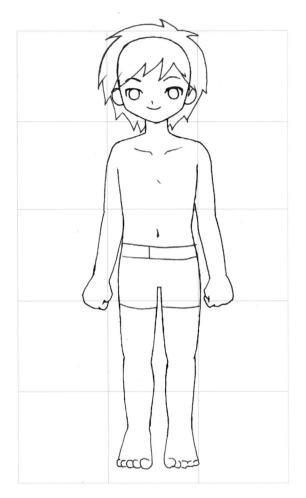

Refine the toes and add collarbones. Start drawing the hair, which should be bigger than the head. Draw a basic outline of the clothes.

This short-sleeve shirt should look like it's tucked in to shorts.

Add collar details and draw the shorts.

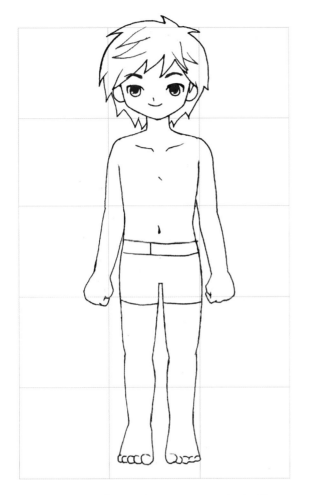

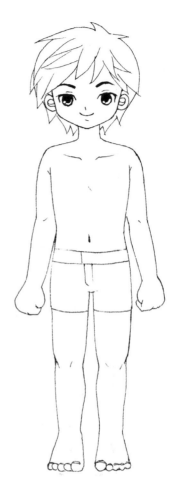

Add some details to the eyes and hair. Give him thicker eyebrows.

Add a few small details to his clothes and hair.

Add a belt and pockets.

The belt looks better in a dark color, don't you think?

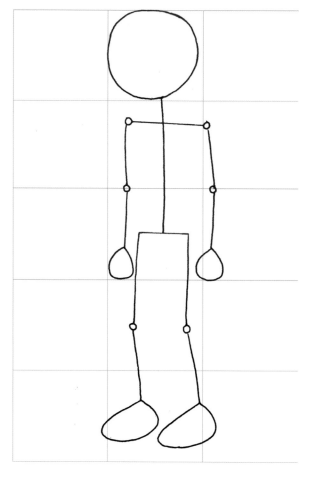

Draw a stick figure, rotated a bit toward the side. Remember to draw broader shoulders. Draw circles where the joints are located.

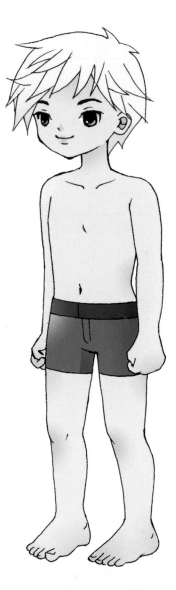

Three-Quarter View

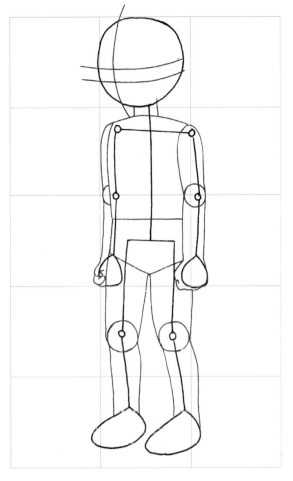

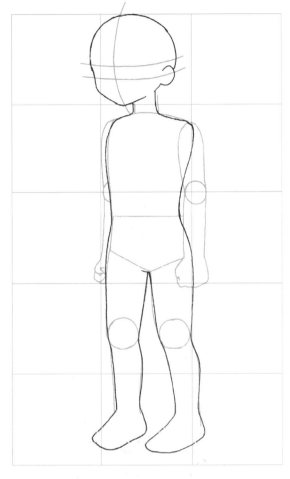

Draw a basic outline for the body, with guidelines for the eye placement. Don't forget that the neck should be bigger than a girl's of the same age.

Refine the body, leg, and head shapes.

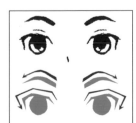

A young boy's eyes have thick eyebrows and turn up at the outer corners.

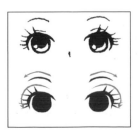

A young girl's eyes have long eyelashes and small, thin eyebrows.

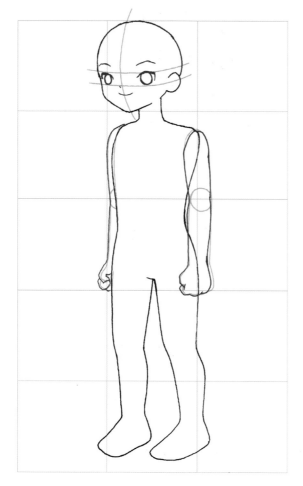

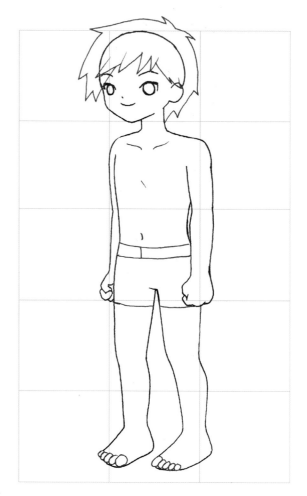

Refine the arms, and add a nose, a mouth, and eyes. For the ¾ view, the eye nearest the reader will look bigger.

Draw the toes and collarbones. Start drawing the hair, which should be bigger than the head. Draw a basic outline of the clothes.

The hat bill should barely cover the eyebrows.

The front panel of the hat should be a bit higher than the hair.

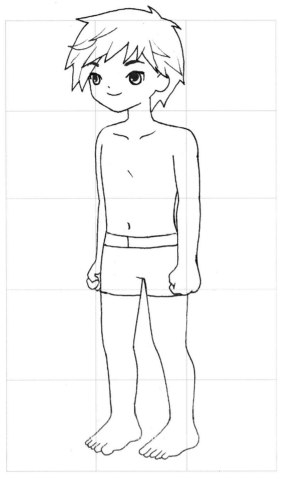

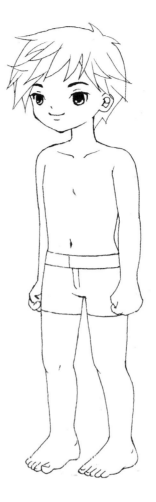

Add some details to the eyes and hair. Refine the feet.

Add a few small details to his clothes and hair.

Draw a rounded back panel.

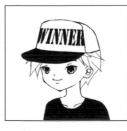

Details make the hat unique.

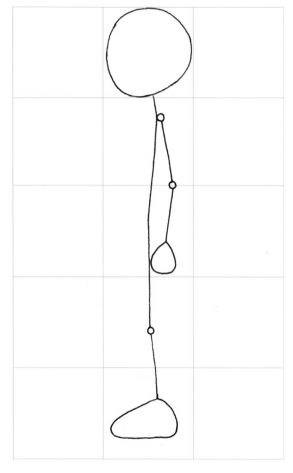

Draw a stick figure, rotated for a side view. Remember to make the face longer than for a toddler. Draw circles where the joints are located.

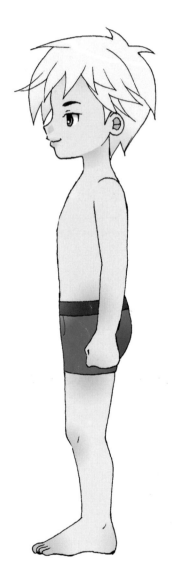

Side View

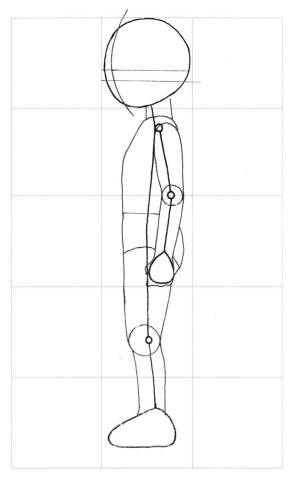

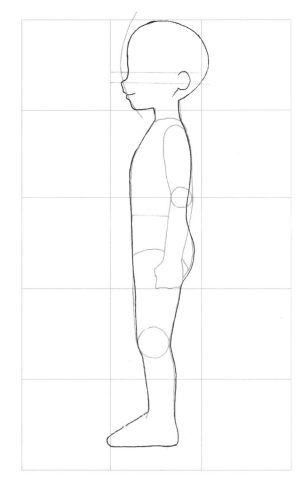

Draw a basic outline for the body, with guidelines for the eye placement. At this age, the male body will look thicker and more muscular from the side.

Refine the body, leg, and head shapes. Draw a small nose, but make it a bit longer than a toddler's nose.

The girl has wider hips and a smaller waist.

The boy has wider shoulders and a stronger torso.

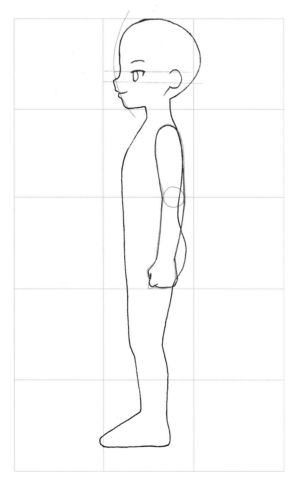

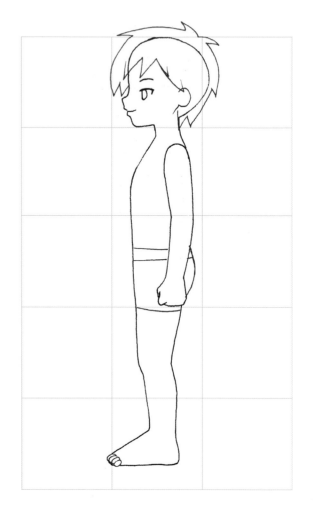

Refine the arms and face. Only one eye is visible. The ear should be fully visible.

Start drawing the hair, which should be bigger than the head. Draw a basic outline of the clothes. Add the toes.

Time to dress your boy.

The sweater should have long sleeves and a v-neck, and fit close to the body.

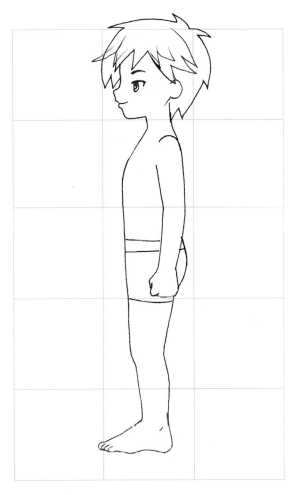

Add some details to the eyes and hair. Refine the feet.

Add a few small details to his eyes, hair, and clothes.

Add ribbing at the collar and a shoulder seam. Add wrinkles at the sides. Draw simple shorts.

Don't forget pockets on the shorts!

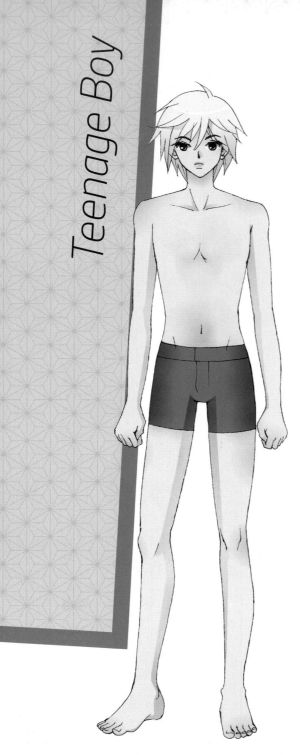

Teenage Boy

Front View

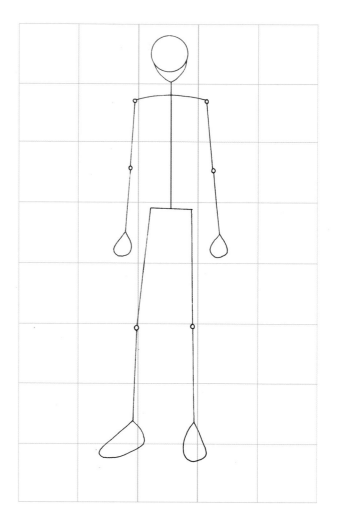

Draw a stick figure that is taller and has broader shoulders. Hands and legs are longer. For longer basic face, draw an extension guide for his jaw.

A teenage boy's body will be stronger, more muscular, and taller than a young boy. But since the muscles are not fully developed, he is still skinny.

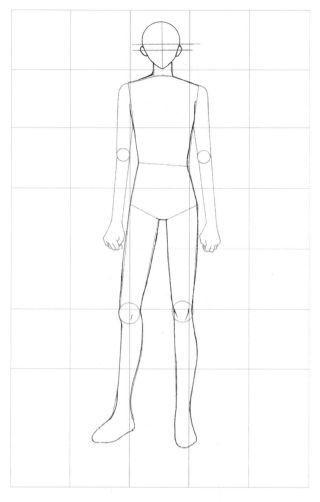

Draw a basic outline for the body, with guidelines for the eye placement. Draw the face a bit longer with a defined jawline. The neck is thicker. Add fingers.

Refine the body, leg, and head shapes. Add ears.

A teen boy's body shape has smaller shoulders and a thin chest; the muscles are not fully built.

A man's body shape has wider shoulders and a muscular chest. The waist is the same size.

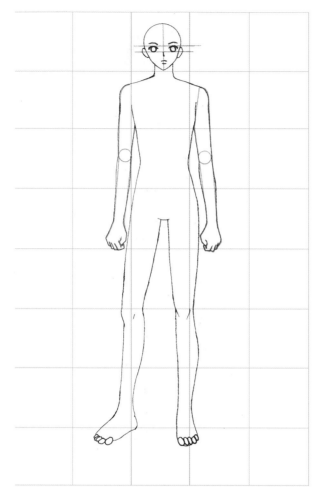

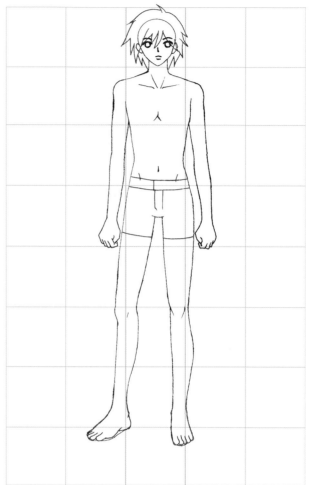

Refine the arms, and add eyes, a nose, and a mouth. Draw the toes.

Refine the toes. Start drawing the hair, which should be bigger than the head. Draw a basic outline of the clothes. Add collarbones, and chest and stomach muscles.

Start with basic feet.

The sole should have uniform thickness.

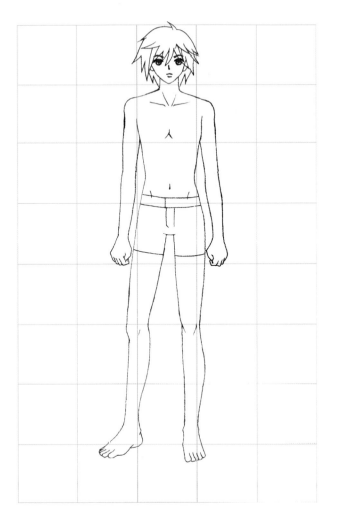

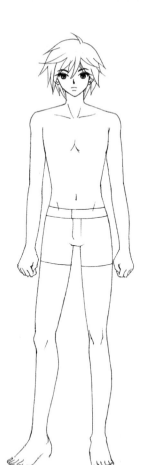

Add some details to the eyes and hair.

Add a few small details to his hair.

At this angle, the outside strap will look much longer.

Now the sandals are finished.

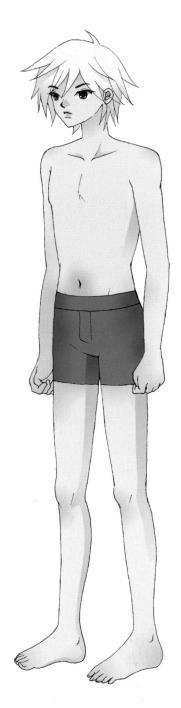

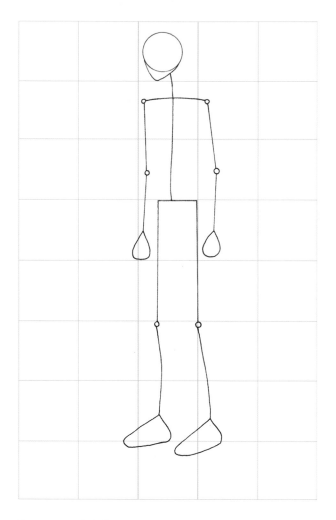

Draw a stick figure, rotated a bit toward the side. Remember, a teenage boy has a longer torso and longer legs. For longer basic face, draw an extension guide for his jaw. Draw circles where the joints are located.

Three-Quarter View

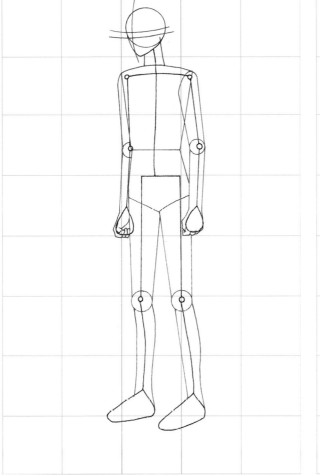

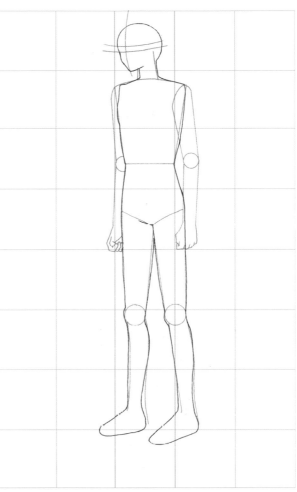

Draw a basic outline for the body, with guidelines for the eye placement. The teen has a thicker neck, broader shoulders, and slimmer waist.

Refine the body, leg, and head shapes. Don't draw the thighs too big, or he'll look feminine.

A teen boy's body shape is thicker with wider shoulders, though muscles haven't fully grown.

A teen girl's body shape is curvier at the hips and chest.

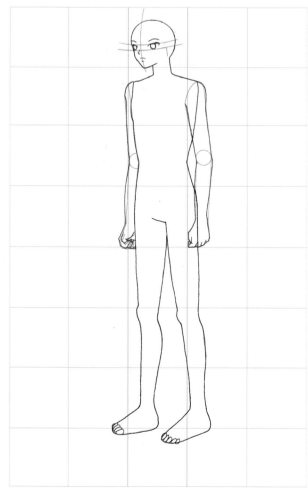

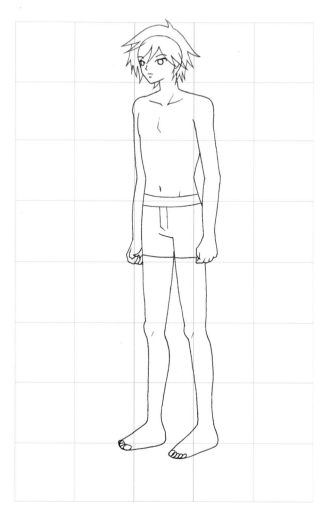

Refine the arms, and add eyes, a nose, and a mouth. For the ¾ view, the eye nearest the reader will look bigger. Draw the toes.

Start drawing the hair, which should be bigger than the head. Draw a basic outline of the clothes. Add collarbones, and chest and stomach muscles.

This sneaker has a flat sole.

Draw the basic outline.

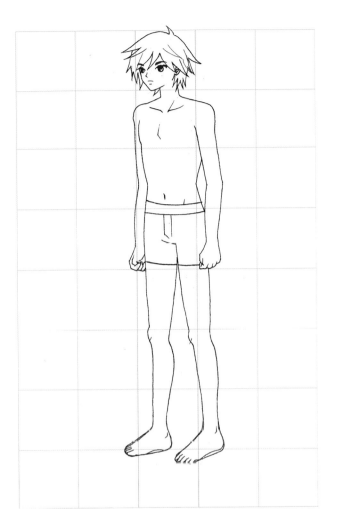

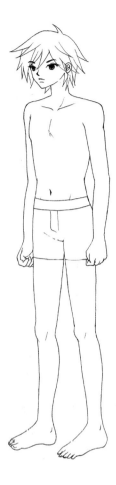

Add some details to the eyes and hair. Refine the feet.

Add a few small details to his hair.

Add details such as seams.

Here's the finished shoe.

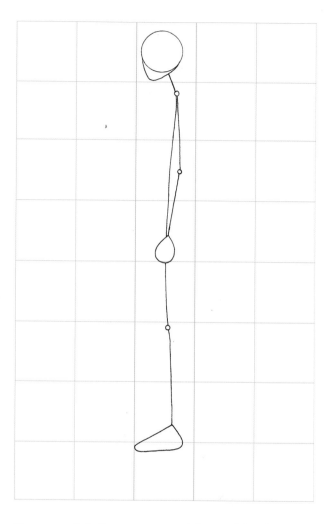

Draw a stick figure, rotated for a side view. For longer basic face, draw an extension guide for his jaw. Draw the face a bit longer with a defined jawline. Draw circles where the joints are located.

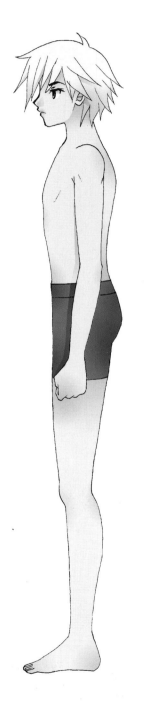

Side View

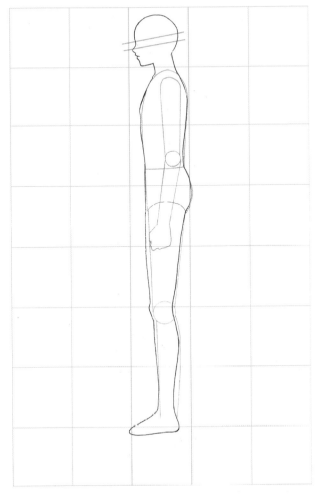

Draw a basic outline for the body, with guide-lines for the eye placement. At this age, the male body will look thicker and more muscular from the side. His upper arms start showing slight muscle.

Refine the body, leg, and face shapes.

From the side, a teen boy's body shape is thick and solid, a sign that he is getting stronger.

From the side, a teen girl's body shape is much curvier.

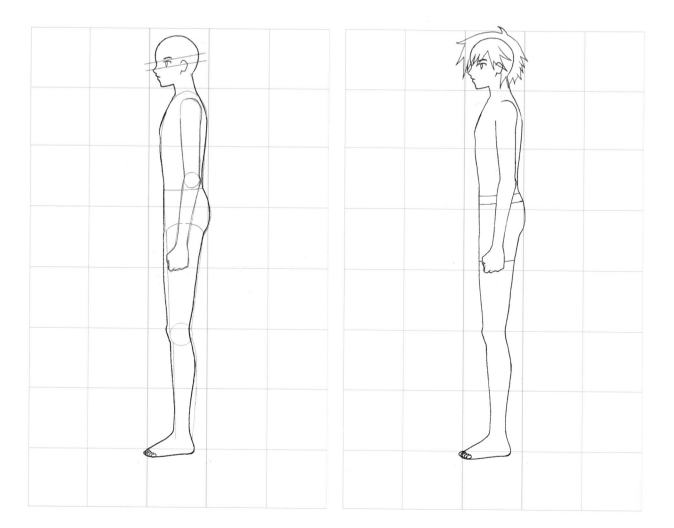

Refine the arms and face. Only one eye is visible. The ear should be fully visible. Draw the toes.

Start drawing the hair, which should be bigger than the head. Draw a basic outline of the clothes.

Start with basic feet.

This angle gives a great view of the curve of the sole.

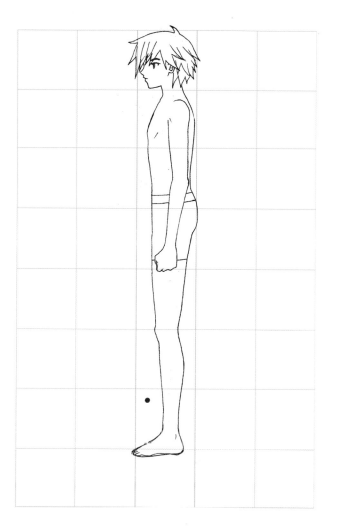

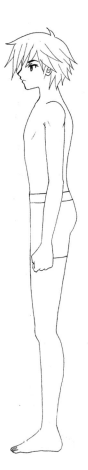

Refine the feet, and add some details to the eyes and hair.

Add a few small details to his hair.

From the side, you can barely see the inside strap.

Time to hit the beach!

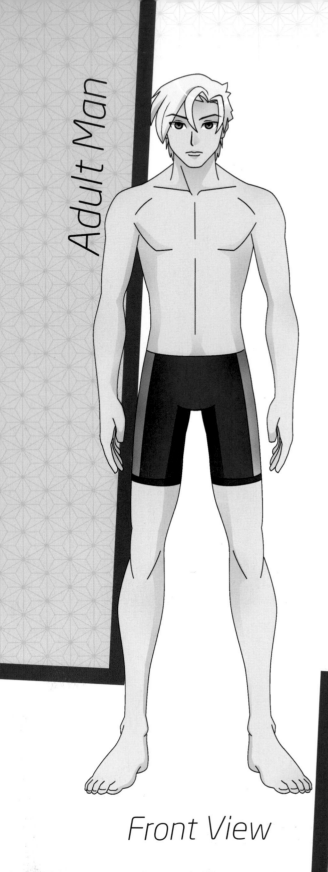

Adult Man

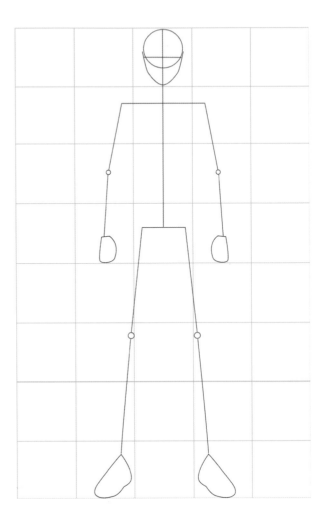

Draw a stick figure that is much taller than a woman. Be sure to include a defined jaw. Draw circles where the joints are located.

Front View

An adult man has broad shoulders, strong arms and legs, a strong jaw, and a longer face and nose.

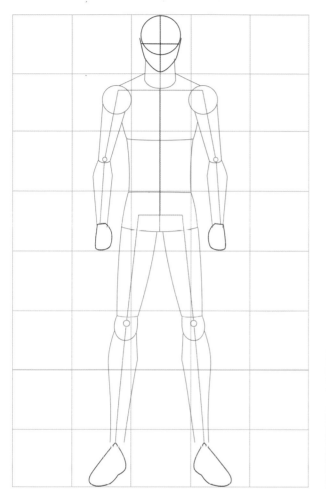

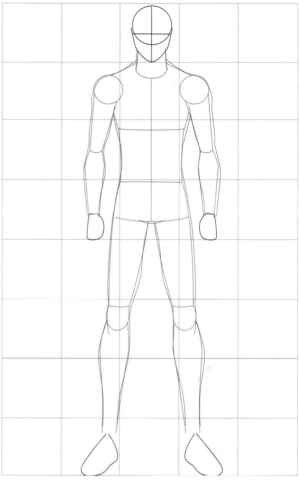

Draw a basic body with muscles. The neck should be almost the same width as the head. The shoulders should be wider than the hips.

Refine the body, arms, and legs.

A teen boy's face is an oval with a pointy chin.

A man has a longer face with a square jaw.

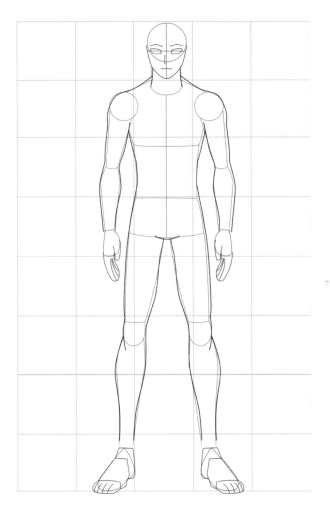

Draw basic hands and feet. Start a basic face.

Draw his hair. Refine the facial features, hands, and feet. Add collarbones, and chest and stomach muscles. As you add clothes, refine the knees.

Draw a basic jacket with a collar.

Add some wrinkles and seams.

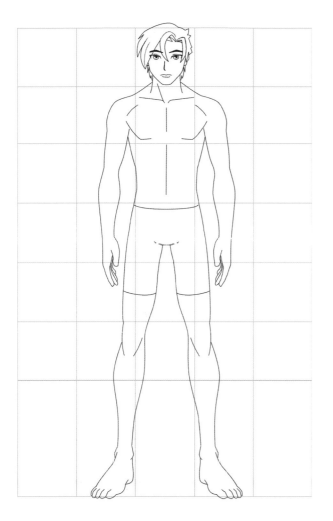

Add details to the hair and face.

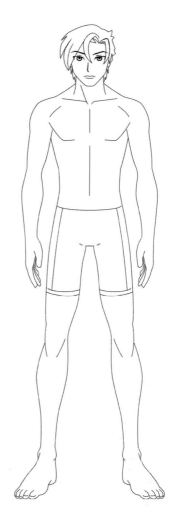

Add a few small details to his clothes and hair.

Don't forget the side pockets.

The jacket is finished.

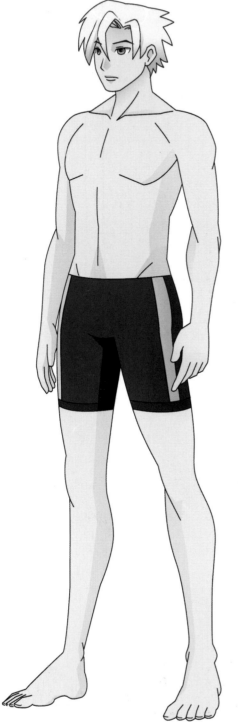

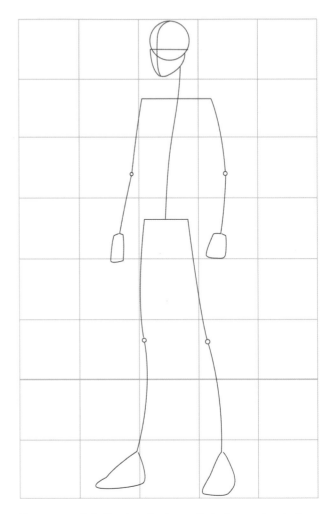

Draw a stick figure facing slightly to the left. The spine will look a bit bent toward the right. Draw circles where the joints are located.

Three-Quarter View

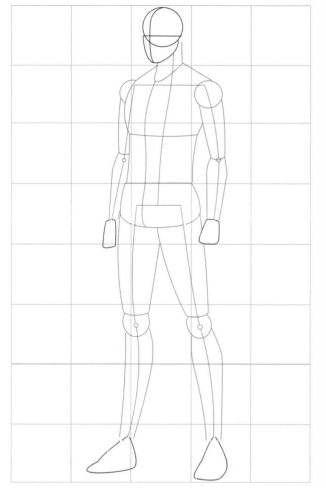

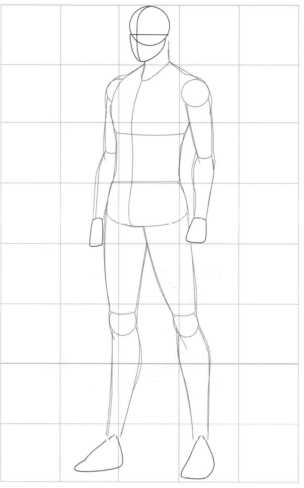

Draw a basic body with muscles. The neck should be almost the same width as the head. The chest and abdomen should be thick to accommodate muscles.

Refine the body, arms, and legs.

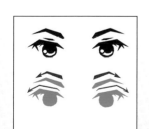

A teen boy's eyes have bigger irises and shorter eyebrows.

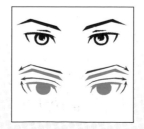

A man's eyes have smaller irises, but longer eyelids and eyebrows.

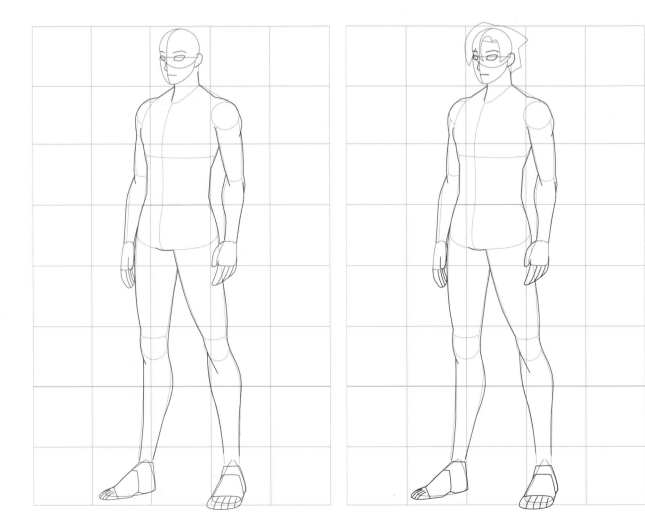

Add a nose, mouth, and eyes. For the ¾ view, the eye nearest the reader will look bigger. Draw basic hands and feet.

Draw his hair.

Draw the basic lines for loose-fitting trousers.

Add details at the waistband.

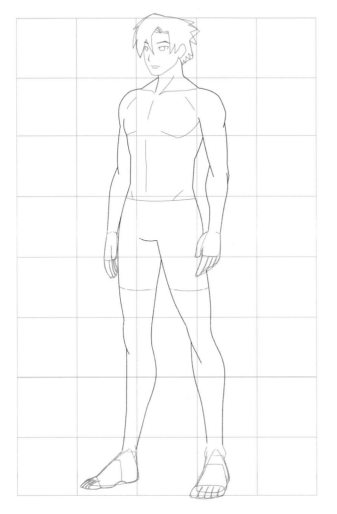

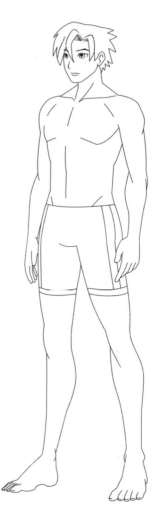

Refine the hair and face. Draw collarbones and chest and stomach muscles. Add clothes.

Add a few small details to his clothes and hair.

This thin, sometimes slippery fabric will have more wrinkles.

Ready for a workout!

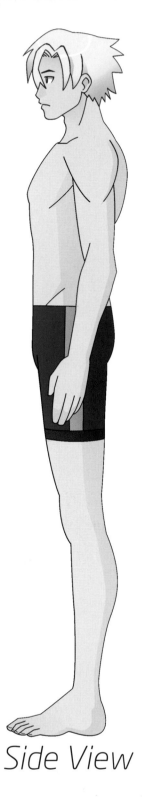

Side View

Draw a stick figure. From the side, the spine will look slightly bent. The jaw will be more visible. Draw circles where the joints are located.

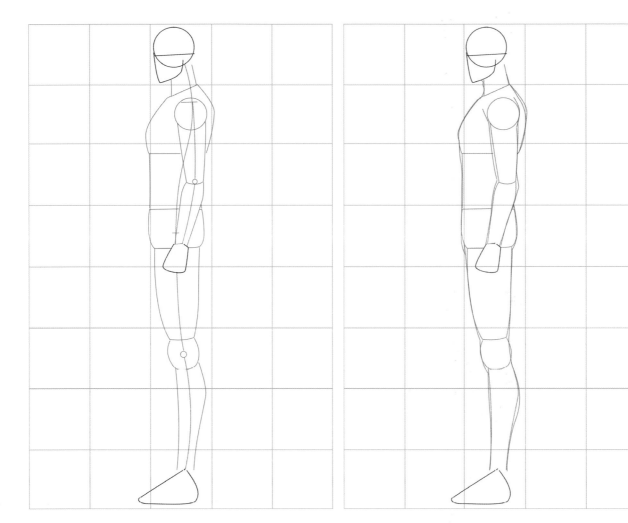

Draw a basic body with muscles. The neck should be almost the same width as the head. The chest and abdomen should be thick to accommodate muscles.

Refine the body, arms, and legs.

From the side, a teen boy's body shape is much thinner.

From the side, a man's body shape is thicker because the chest and shoulder muscles are fully developed.

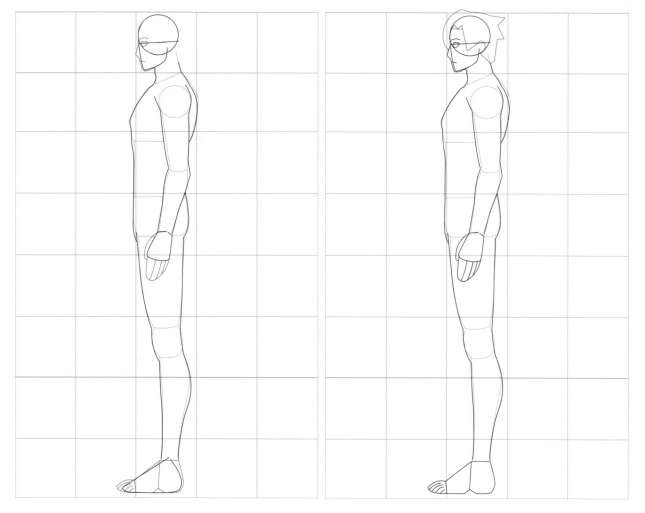

Draw basic hands and feet. Start a basic face. Only one eye will be visible.

Draw his hair.

Trainers have thin soles that curve up at the toes.

Add stitching and holes for the laces.

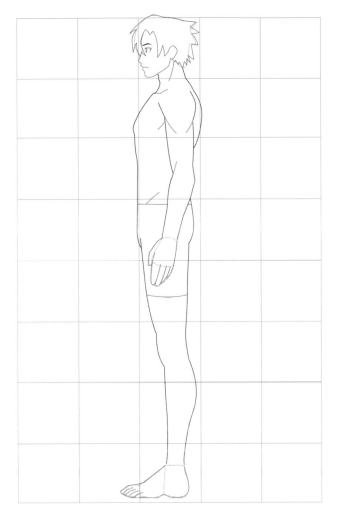

Refine the hair and face. Draw a collarbone and add muscles to the arm and torso. Add clothes. Refine the hands and feet.

Finish with details to his hair, eye, ear, and clothes.

Add shoelaces.

Make sure you have loops at the top— these shoes are tied.

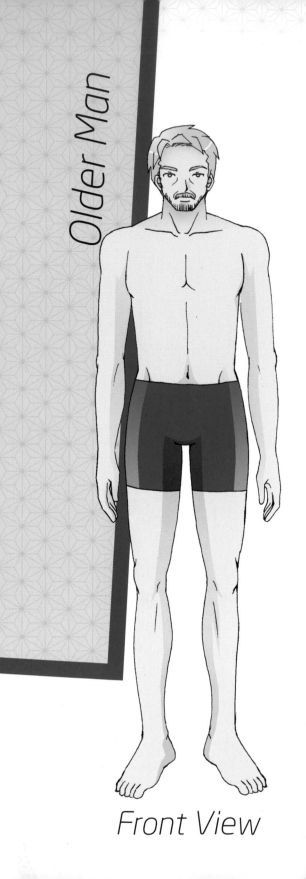

Older Man

Front View

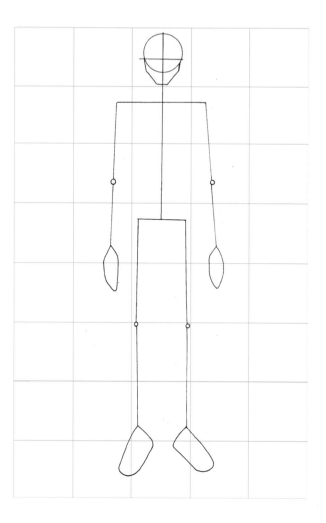

Draw a stick figure that's a bit shorter than an adult man. Draw circles where the joints are located.

An older man's body is still muscular, but will thicken a bit.

Draw a basic body with muscles. The neck should be almost the same width as the head. The shoulders should be wider than the hips. Make the waist and thighs wider than for an adult man.

Refine the body, arm, and leg shapes.

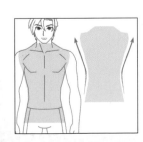

A young man has a muscular body with a slim waist.

An older man has a more bulky body and a bigger waist.

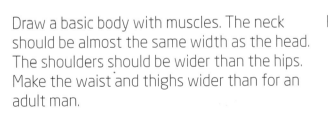

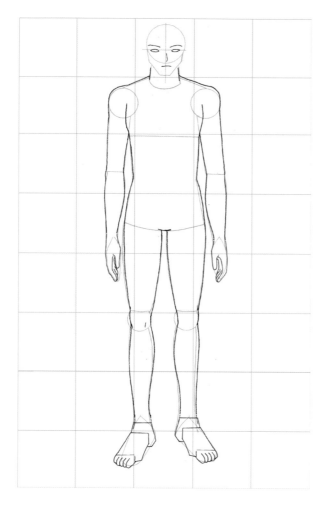

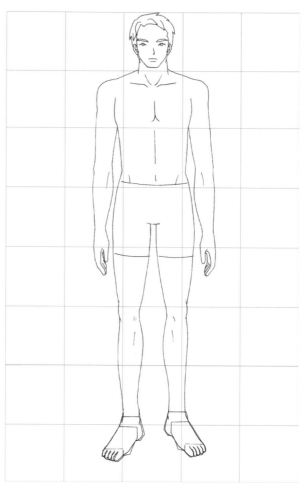

Refine the hands and feet. Start a basic face.

Start drawing the hair. Refine the eyes, nose, and mouth. Add collarbones, and chest and stomach muscles. As you add clothes, refine the legs and knees; the legs should be slightly bigger than the knees.

Time to dress your older man.

Draw the outline of a short-sleeve t-shirt.

Refine the hair. Draw wrinkles on his face. Add a beard and mustache.

Just add a few small details to his hair.

Add a collar and some wrinkles.

Your t-shirt is finished.

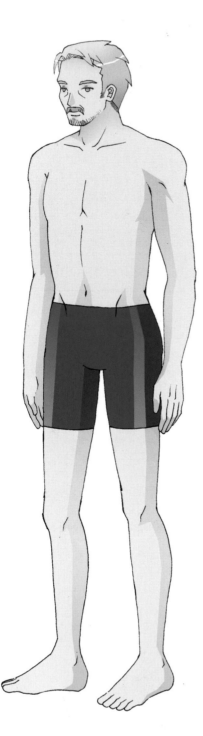

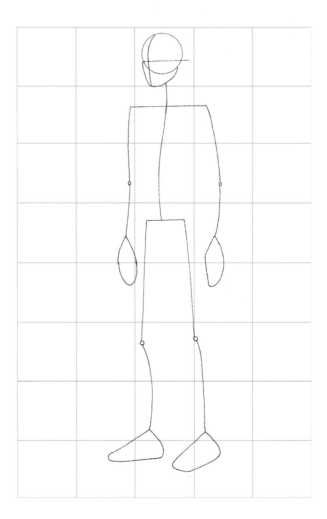

Draw a stick figure, rotated a bit toward the side. Draw circles where the joints are located.

Three-Quarter View

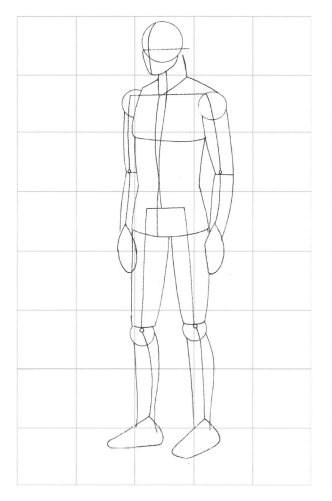

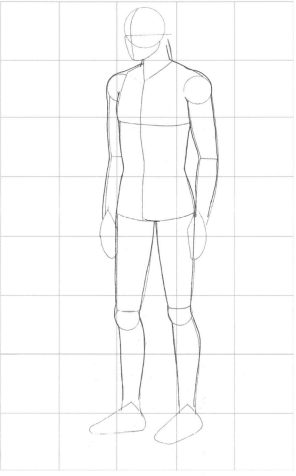

Draw a basic body with muscles. The neck should be almost the same width as the head. The waist and thighs will be wider than for an adult man.

Refine the body, arm, and leg shapes.

A young man has a long, thin face.

An older man has a more rectacgular jaw with smaller eyes.

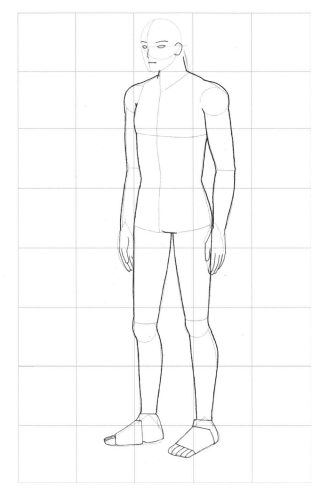

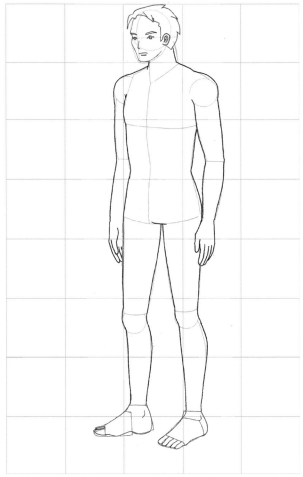

Refine the hands and feet. Start a basic face. For the ¾ view, the eye nearest the reader will look bigger.

Start drawing the hair. Refine the eyes, nose, and mouth. Finish refining the feet.

Start with a basic figure.

Draw the outline of a trench coat.

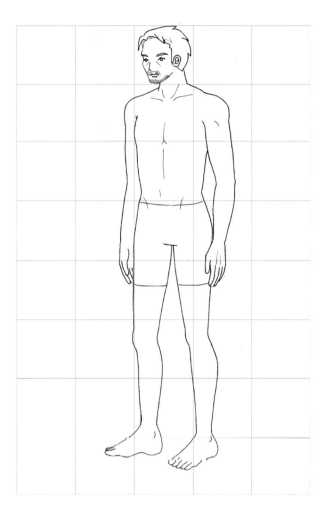

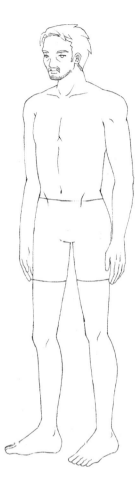

Refine the hair. Add collarbones, and chest and stomach muscles. Draw wrinkles on his face. Add a beard and mustache. Begin clothing.

Just add a few small details to his hair.

Add a large collar, a belt, and wrinkles.

He looks handsome in his new coat.

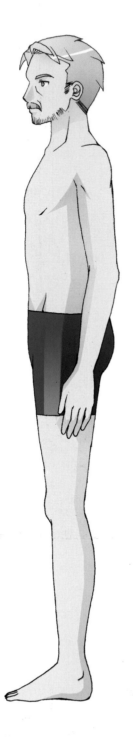

Draw a stick figure. From the side, the spine will look slightly bent. The jaw will be more visible. Draw circles where the joints are located.

Side View

Draw a basic body with muscles. The neck should be almost the same width as the head. His body is getting thicker, so the torso should have a bit more bulge.

Refine the body, arm, and leg shapes.

Draw the soles and the basic shape of the boots.

Smooth the shape, and add the tops. Add stitching lines.

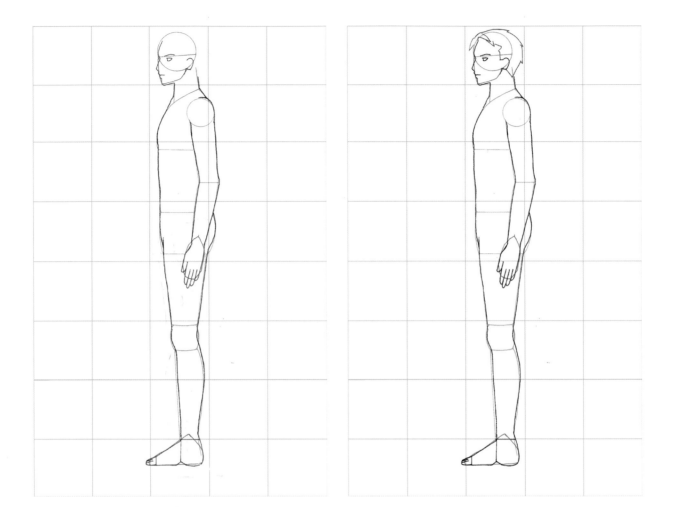

Refine the hands and feet. Start a basic face. Only one eye will be visible in this view.

Start drawing the hair.

Draw buckles across the top of the feet.

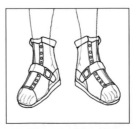

Add the holes for shoelaces.

Refine the hair and face details. Add wrinkles, a mustache, and a beard to his face. Draw clothes.

Just add a few small details to his hair.

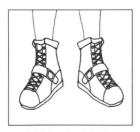

Add the shoelaces.

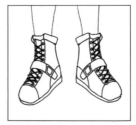

Your boots are done.

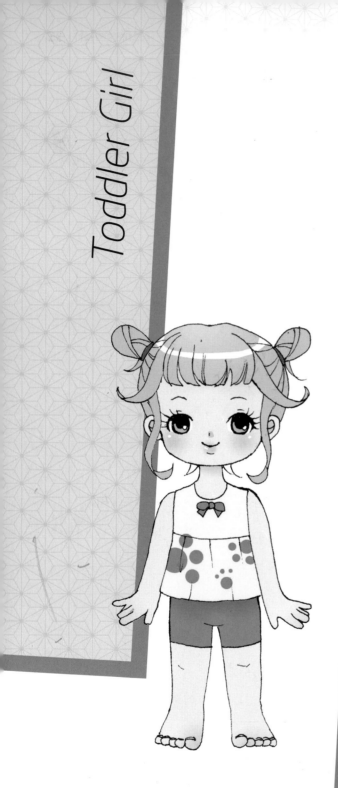

Draw a stick figure with a big head and short body. It should have small legs and arms. Draw circles where the joints are located.

A toddler has a large head, big eyes, and a body almost the same size as the head. They are similar to chibi characters, but an anime toddler will have more realistic hands and feet.

Draw a basic outline for the body, with guidelines for the eye placement.

Refine the body, leg, and head shapes. Add ears.

At first glance the difference won't stand out. But an artist should see it.

A boy's body is rectangular.

A girl's body is trapezoidal—wider at the bottom.

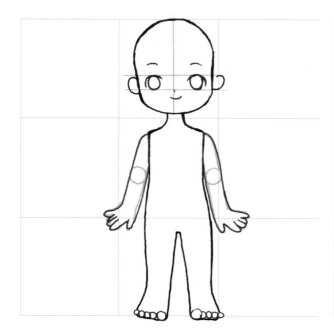

Refine the arms, and add eyes, a nose, and a mouth. Draw the toes.

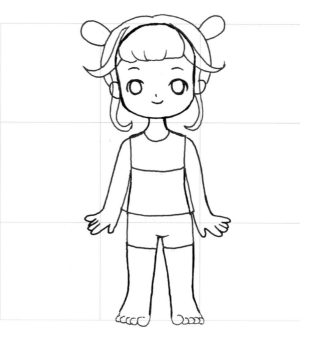

Refine the toes. Start drawing the hair, which should be bigger than the head. Draw a basic outline of the clothes.

Draw an oval for the palm, and a basic arm.

Add ovals for fingers.

Add some details to the eyes, hair, and shirt.

Add a few small details to the clothes and hair.

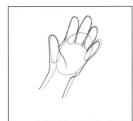

Smooth the lines. Curve in to form a wrist. Extend the thumb line into the palm.

Here's how the hand should look.

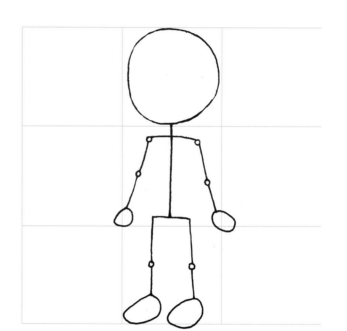

Draw a stick figure, rotated a bit toward the side. Draw circles where the joints are located.

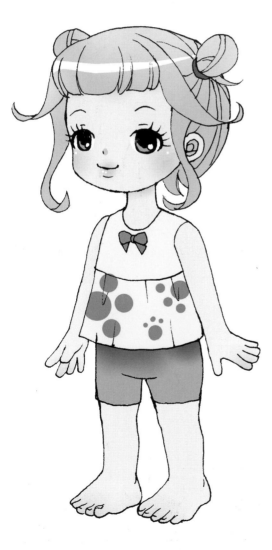

Three-Quarter View

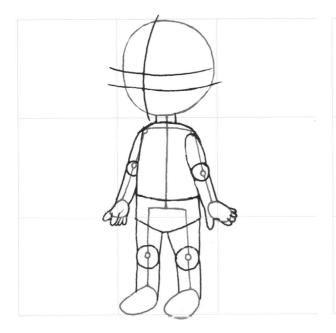

Draw a basic outline for the body, with guidelines for the eye placement.

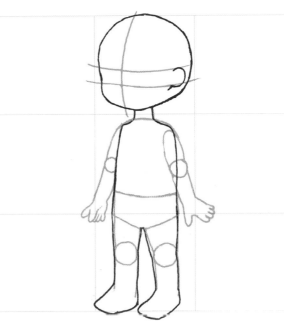

Refine the body, leg, and head shapes. Add the ear.

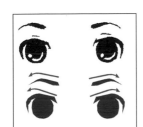

Boys' eyes will have thicker eyebrows, heavier eyelids, and no eyelashes. The eyes curve up at the outer corners.

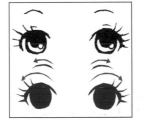

Girls' eyes will have long eyelashes and small, thin eyebrows. The eyes curve down at the outer corners.

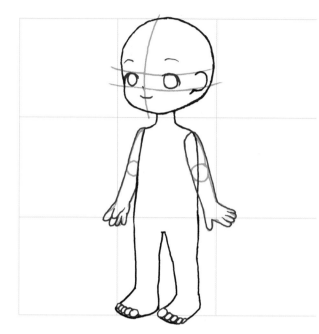

Refine the arms, and add a nose, a mouth, and eyes. For the ¾ view, the eye nearest the reader will look bigger. Draw toes.

Refine the toes. Start drawing the hair, which should be bigger than the head. Draw a basic outline of the clothes.

The dress should flare out at the knees. Add long sleeves and a cape over her shoulders.

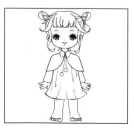

Add wrinkles on the dress. Draw the ribbons that tie the cape closed.

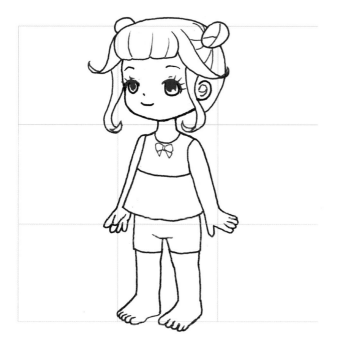

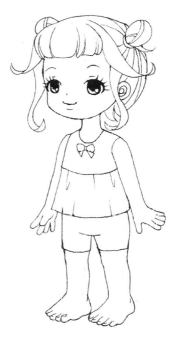

Add some details to the eyes, ear, hair, and shirt.

Add a few small details to the clothes and hair.

Add a bow at the collar. Draw boots.

Time to play in the snow!

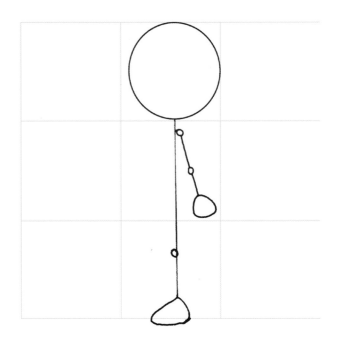

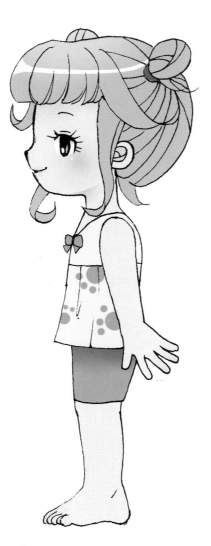

Draw a stick figure, rotated for a side view. Draw circles where the joints are located.

Side View

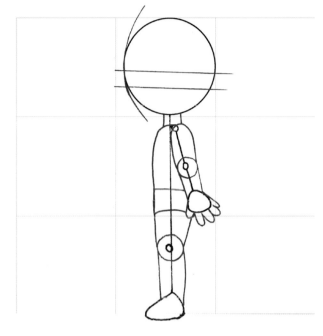

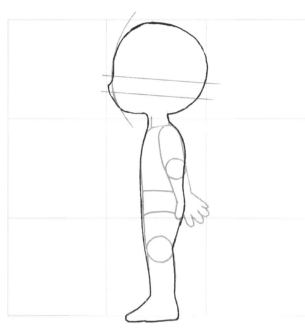

Draw a basic outline for the body, with guide-lines for the eye placement.

Refine the body, leg, and head shapes. Draw a very tiny nose.

A young girl's face is shaped like an oval with a slightly tapered chin.

A toddler's face is chubby and round with no chin at all.

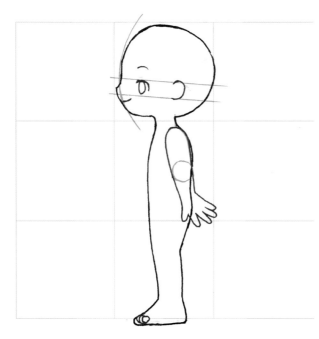

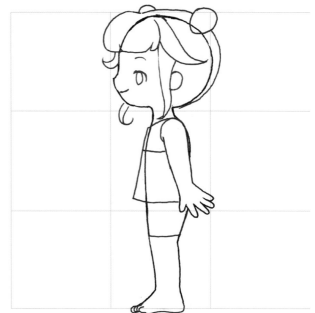

Refine the arms and face. Only one eye is visible. The ear should be fully visible. Draw the toes.

Refine the toes. Start drawing the hair, which should be bigger than the head. Draw a basic outline of the clothes.

You can draw a cute dress for your toddler.

The dress should have a v-neck and an a-line skirt that floats away from the body at the knee. Make a line for the empire waist.

Add some details to the eyes, ear, hair, and shirt.

Add a few small details to the clothes and hair.

Add a sailor collar, small tie, and puff sleeves. Add wrinkles in the skirt.

Isn't she cute?

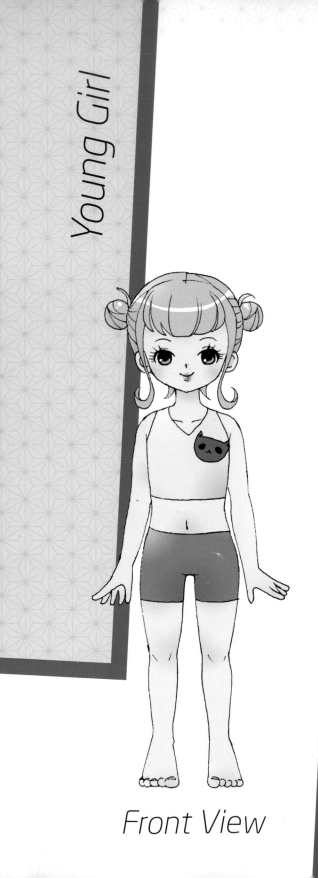

Front View

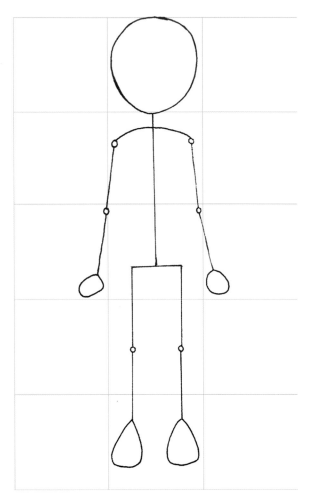

Draw a stick figure with a longer face and taller body. Arms and legs are also longer. Draw circles where the joints are located.

An older girl has a longer face compared to a toddler. At this stage, the female body is a bit bigger at the hip and thighs and smaller at the waist.

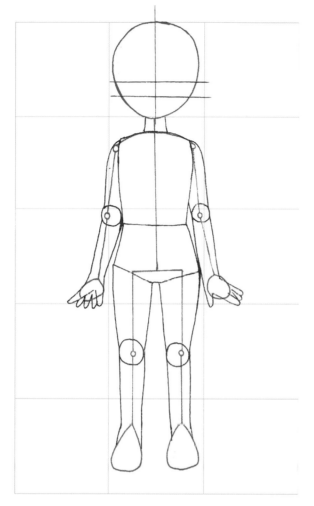

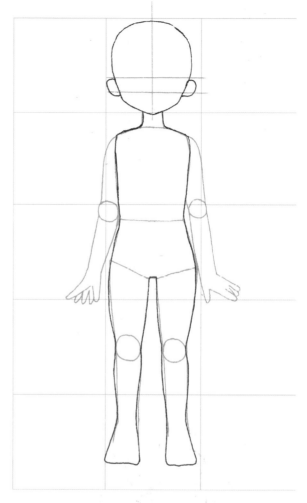

Draw a basic outline for the body, with guidelines for the eye placement.

Refine the body, leg, and head shapes. Add ears.

A toddler's face is chubby and round with no chin at all.

A young girl's face is shaped like an oval with a slightly tapered chin.

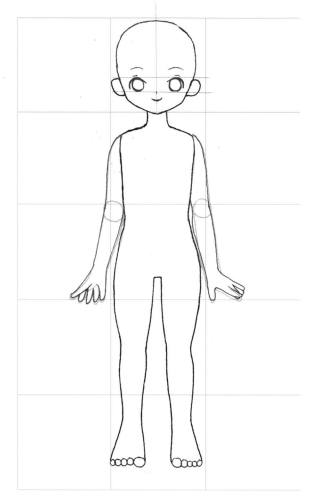

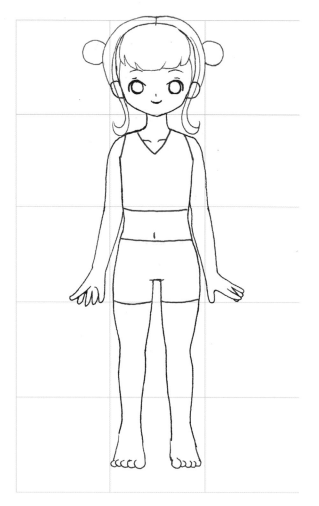

Refine the arms, and add eyes, a nose, and a mouth. Draw the toes.

Refine the toes. Start drawing the hair, which should be bigger than the head. Draw a basic outline of the clothes. Add collarbones.

Start with basic feet.

Draw the outline of shoes, like a half-moon around the toes.

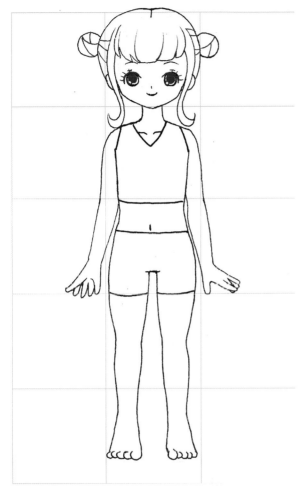

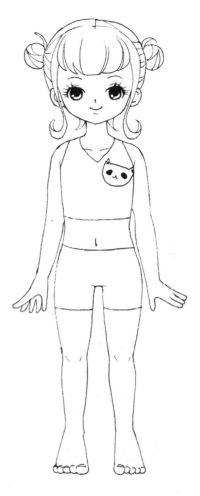

Add some details to the eyes and hair. Add some lines to the buns to show they are made from her hair.

Add a few small details to her clothes and hair.

A thin sole is visible at the toes. There is seaming at the foot.

Here's how the shoes should look.

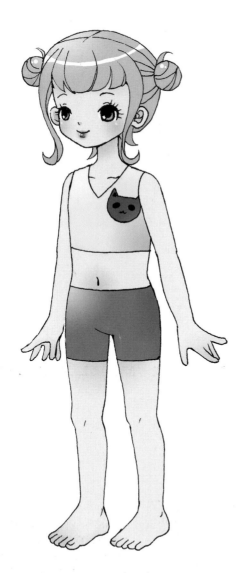

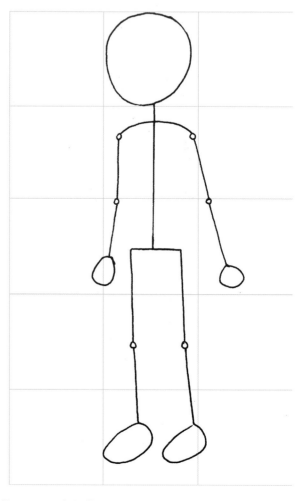

Draw a stick figure, rotated a bit toward the side. Draw circles where the joints are located.

Three-Quarter View

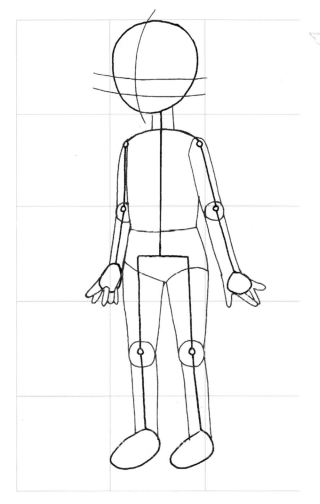

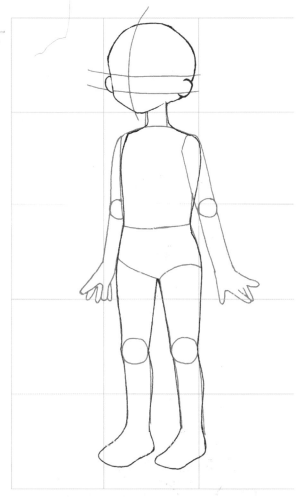

Draw a basic outline for the body, with guidelines for the eye placement.

Refine the body, leg, and head shapes. Add ears.

A toddler is short, with a trapezoidal body shape that is slightly wider at the bottom.

Altough the young girl doesn't have breasts yet, her torso becomes more curvy: it is wider at the hips and smaller at her waist.

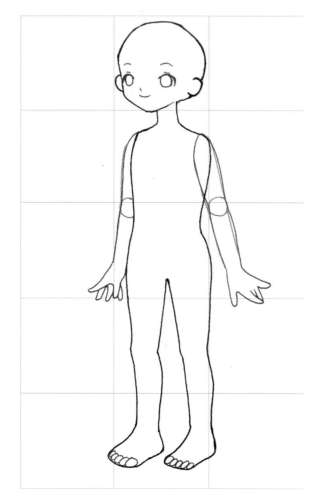

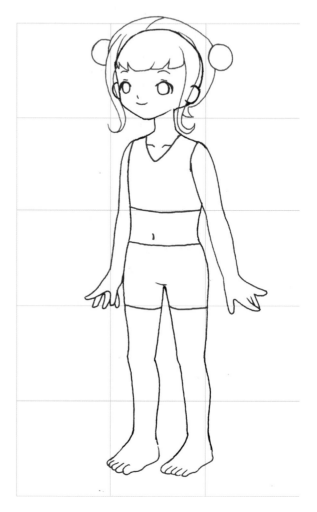

Refine the arms, and add a nose, a mouth, and eyes. For the ¾ view, the eye nearest the reader will look bigger. Draw toes.

Refine the toes. Start drawing the hair, which should be bigger than the head. Draw a basic outline of the clothes. Add collarbones.

Start with basic feet.

Draw a simple outline around the feet.

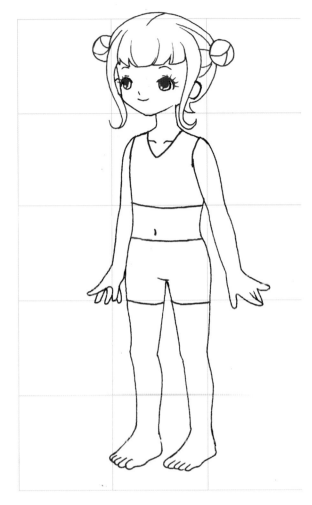

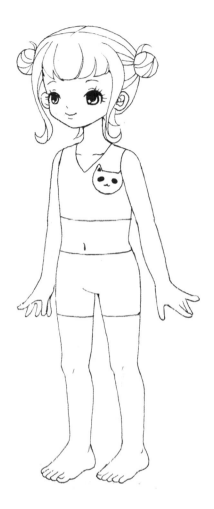

Add some details to the eyes and hair. Add some lines to the buns to show they are made from her hair.

Add a few small details on her clothes and hair.

Draw a thin sole, slightly thicker at the heel. Add seams at the toes and heel.

Here's how the shoes should look.

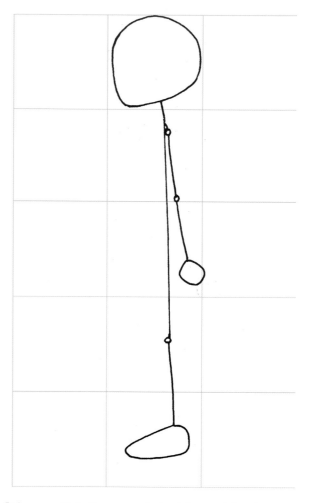

Draw a stick figure, rotated for a side view. Draw circles where the joints are located.

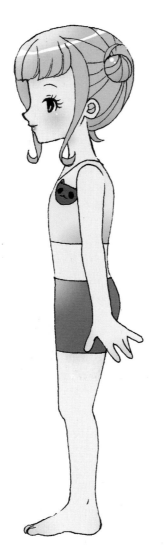

Side View

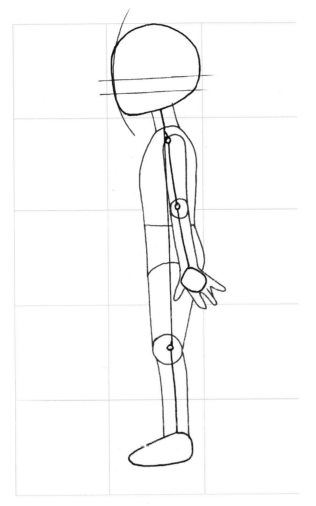

Draw a basic outline for the body, with guidelines for the eye placement. Remember, at this age the female body will look more curvy from the side.

Refine the body, leg, and face shapes. Draw a small nose, but make it a bit longer than a toddler's nose.

From the side, a young boy's body shape is mostly flat.

From the side, a young girl's body shape is curvier.

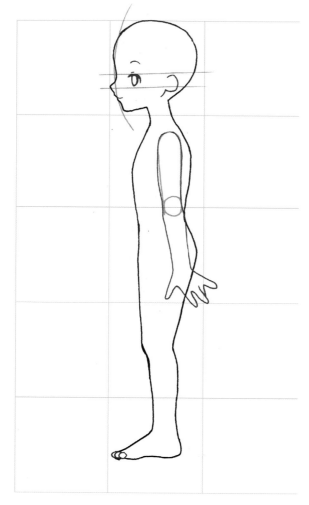

Refine the arms and face. Only one eye is visible. The ear should be fully visible. Add toes.

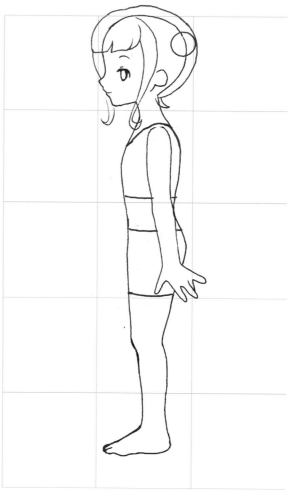

Start drawing the hair, which should be bigger than the head. Draw a basic outline of the clothes. Refine the toes.

Draw a party dress for your young girl.

Draw a simple, short-sleeve dress.

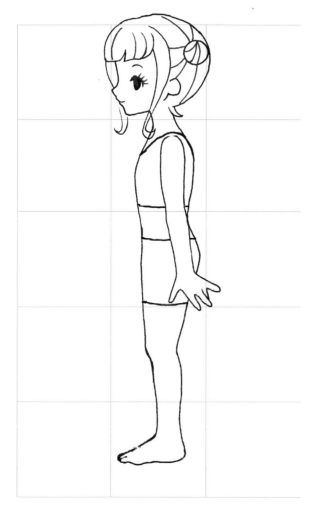

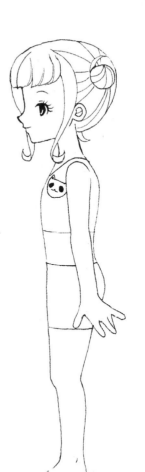

Add some details to the eyes and hair. Add some lines to the bun to show it is made from her hair.

Add a few small details to her hair and clothes.

Add buttons at the collar and ribbon to form an empire waist. The fabric is a heavy velvet, so don't add many wrinkles to the skirt.

The finishing touch to this party dress is a bow at the waist.

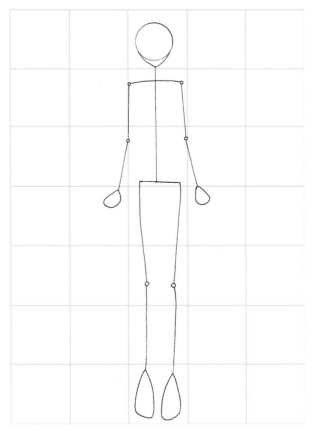

Draw a stick figure that is tall and slender. Draw circles where the joints are located.

A teenage girl's body has bigger hips and thighs, a small waist, and a bigger chest with breasts. The legs and arms grow longer and more slender.

Front View

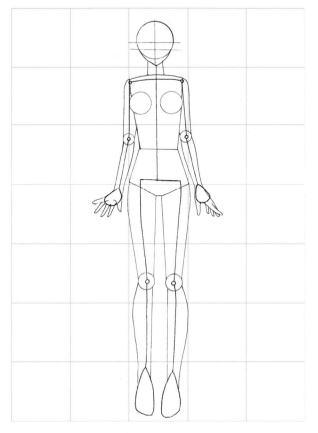

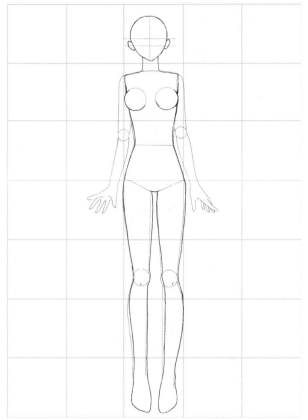

Draw a basic outline for the body, with guidelines for the eye placement. Add two circles on her chest as a guide for drawing breasts. Draw fingers.

Refine the body, leg, and head shapes. Add ears.

A teen girl's body shape has a shorter torso and is less curvy.

A woman's body shape has a longer torso, is more curvy, and nips in more at the waist.

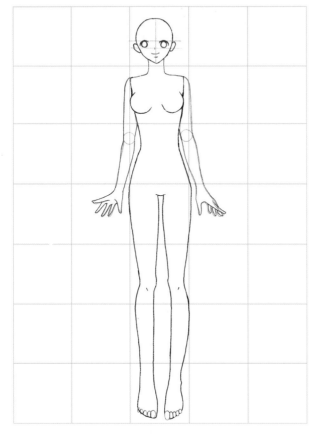

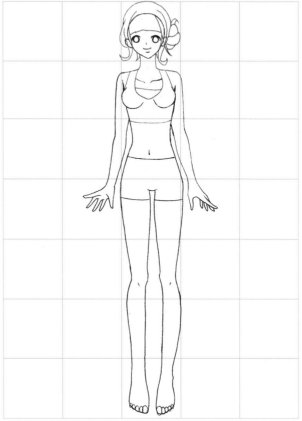

Refine the arms, and add eyes, a nose, and a mouth. Draw the toes.

Start drawing the hair, which should be bigger than the head. Draw a basic outline of the clothes. Add collarbones.

Draw a circle for the back of the hand, and a basic arm. Draw a shoelace almost touching the hand.

The thumb overlaps the shoelace, pinching it to the tip of the first finger. The other fingers are round.

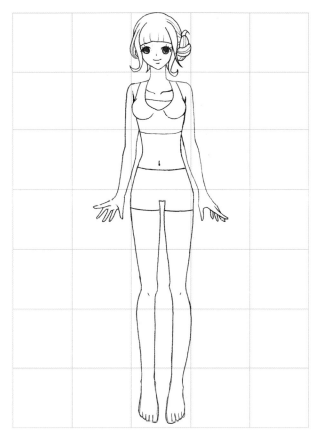

Add some details to the eyes and hair. Add some lines to the bun to show it is made from her hair. Refine the toes.

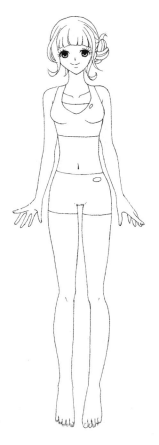

Add a few small details to her clothes and hair.

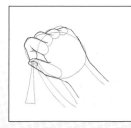

Smooth the lines, curving in for a wrist. Add a thumbnail.

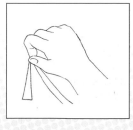

Here's how the hand should look.

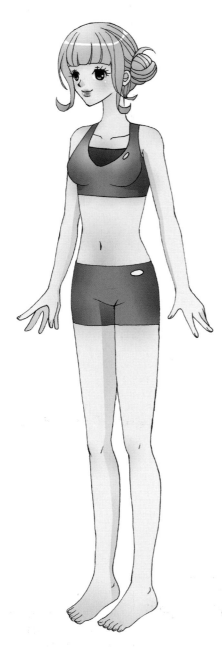

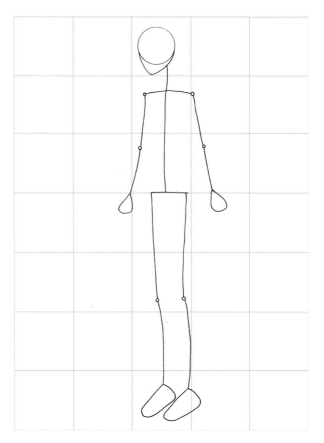

Draw a stick figure, rotated a bit toward the side. Draw circles where the joints are located.

Three-Quarter View

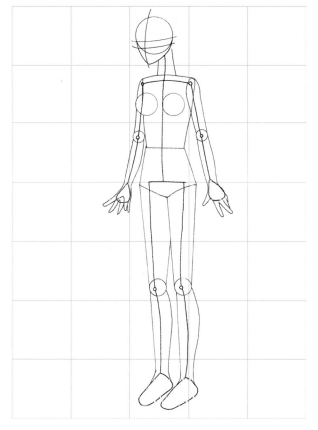

Draw a basic outline for the body, with guidelines for the eye placement. Add two circles on her chest as a guide for drawing breasts. Draw fingers.

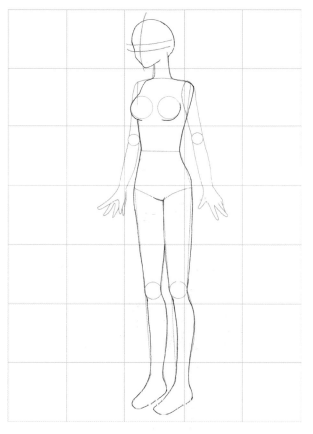

Refine the body, leg, and head shapes.

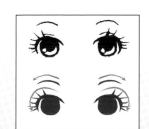

A young girl's eyes have big irises, small eyebrows, and short upper eyelids.

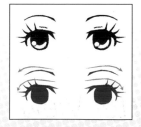

A teen girl's eyes have smaller irises, longer eyebrows, and longer upper eyelds.

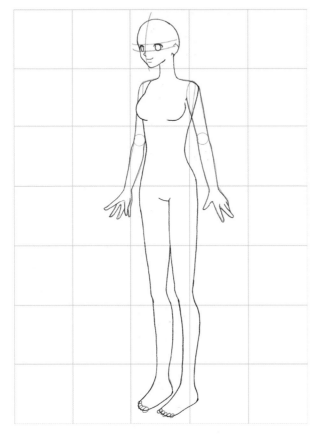

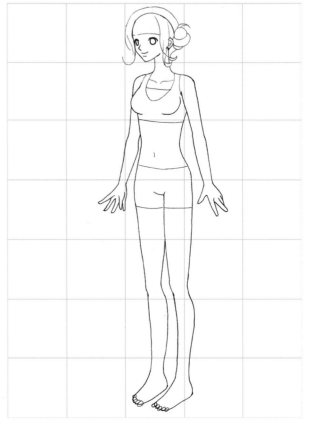

Refine the arms, and add a nose, a mouth, ears, and eyes. For the ¾ view, the eye nearest the reader will look bigger. Draw toes.

Start drawing the hair, which should be bigger than the head. Draw a basic outline of the clothes. Add collarbones

In this view, the heel can be seen.

Add the ankle straps.

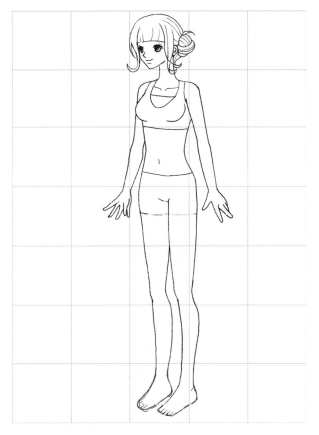

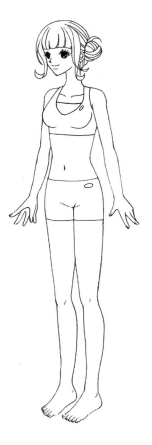

Add some details to the eyes and hair. Add some lines to the bun to show it is made from her hair. Refine the toes.

Add a few small details on her clothes and hair.

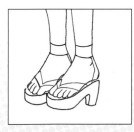

At this angle, the outside strap will look much longer. Add straps at the heel.

Note that the heel is enclosed.

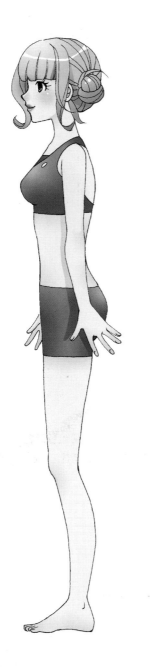

Draw a stick figure, rotated for a side view. Draw circles where the joints are located.

Side View

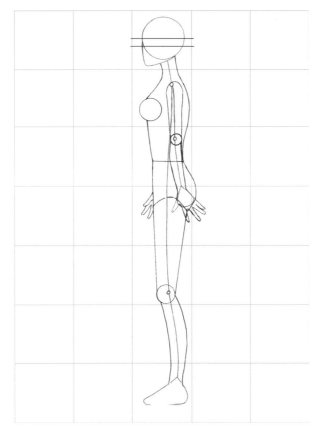

Draw a basic outline for the body, with guidelines for the eye placement. Pay attention to the curvier parts. Add fingers.

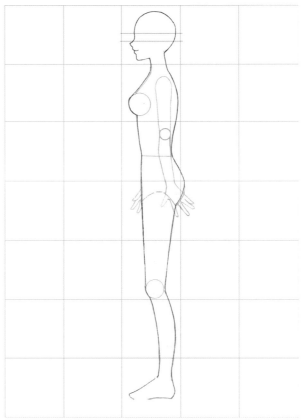

Refine the body, leg, and head shapes. The face should be longer than a girl's, so the nose is also longer.

A young girl's face is round with a small, tapered chin.

A teen girl's face is oval with a pointed chin.

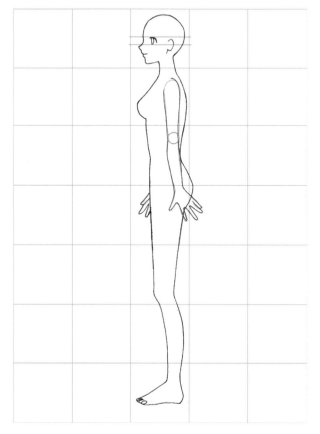

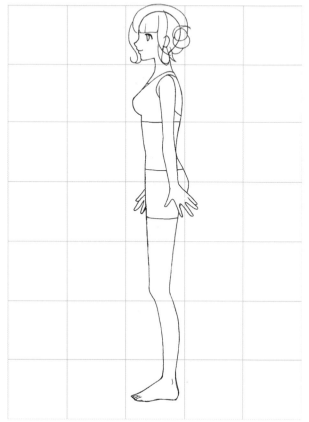

Refine the arms and face. Only one eye is visible. The ear should be fully visible. Add toes.

Start drawing the hair, which should be bigger than the head. Draw a basic outline of the clothes. Refine the toes.

Draw the wedge sole, which should be higher at the heel. Then draw the feet, standing slightly on tiptoe.

Draw the outline of the shoes.

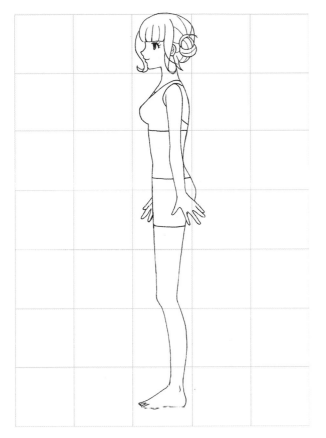

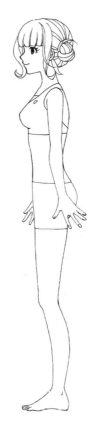

Add some details to the eyes and hair. Add some lines to the bun to show it is made from her hair.

Add a few small details to her eyes, hair, and clothes.

Add details such as seams and bows.

You can color in the toe if you wish.

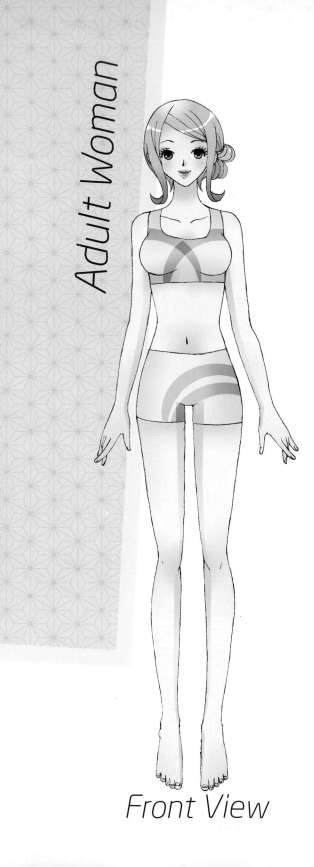

Front View

Draw a stick figure that's taller than a teenage girl. The face is a bit longer, with a stronger jaw. Draw circles where the joints are located.

A woman has bigger breasts, hips, and thighs. Her legs are longer, so the knee looks smaller. Her neck is long and slender.

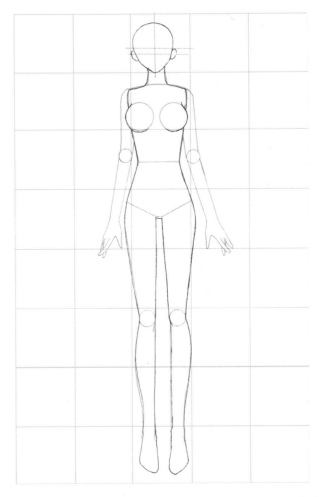

Draw a basic outline for the body, with guidelines for the eye placement. Add two circles on her chest as a guide for drawing breasts, slightly larger than for a teen. Draw fingers.

Refine the body, leg, and head shapes. Add ears.

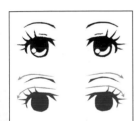

A teen girl's eyes retain some childish features, such as large irises.

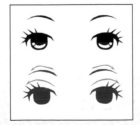

A woman's eyes are smaller and appear farther from the eyebrows.

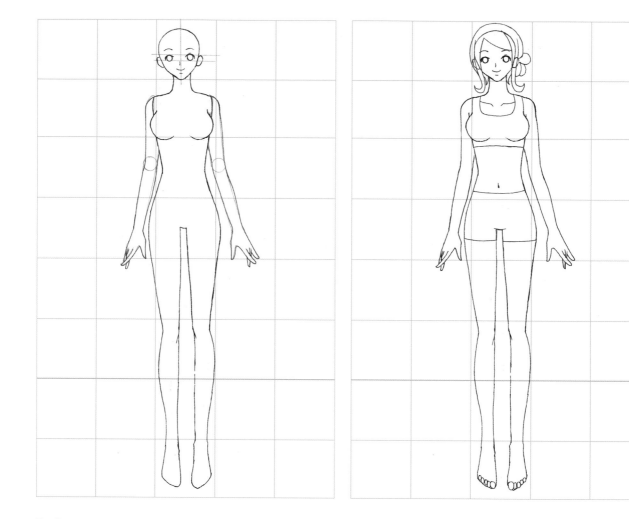

Refine the arms, and add eyes, a nose, and a mouth.

Start drawing the hair, which should be bigger than the head. Draw a basic outline of the clothes. Add the toes and collarbones.

Draw the high sole of the shoes first, then the feet. This way you can adjust the angle of the foot.

Add the ankle straps.

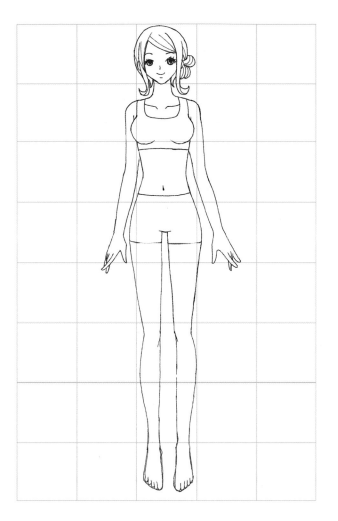

Refine the feet. Add some details to the eyes and hair. Add some lines to the bun to show it is made from her hair.

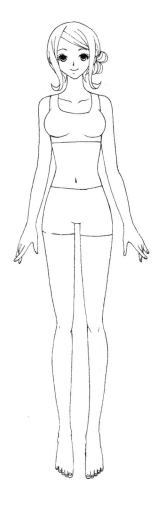

Add a few small details to her hair.

Straps across the top of the foot disappear between toes.

Finish with a detail on the soles.

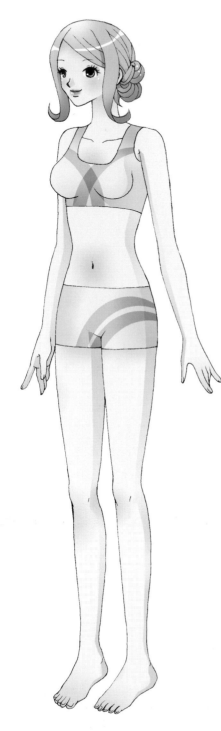

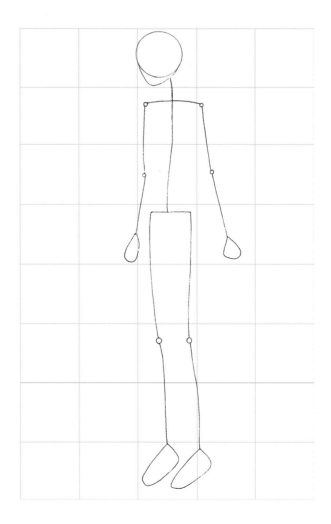

Draw a stick figure, rotated a bit toward the side. Draw circles where the joints are located.

Three-Quarter View

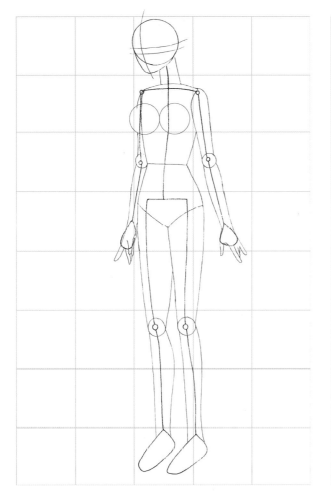

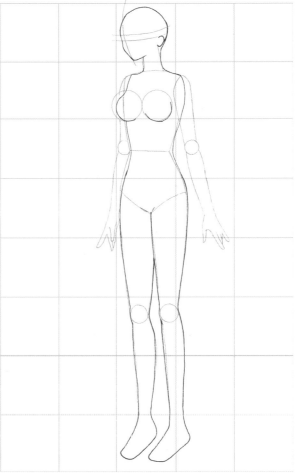

Draw a basic outline for the body, with guidelines for the eye placement. Make hips bigger and the waist smaller. Add two circles on her chest as a guide for drawing breasts. Draw fingers.

Refine the body, leg, and head shapes. Add ears.

A teen girl's face has a pointed chin, but is not as long as an adult's.

A woman's face is longer and the chin is more pointy.

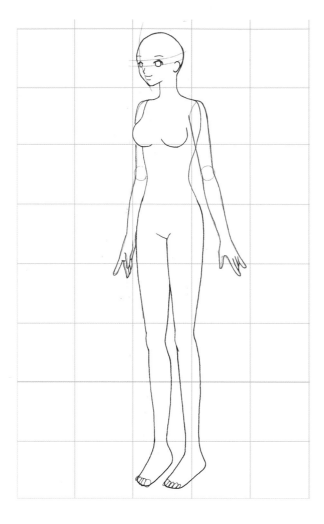

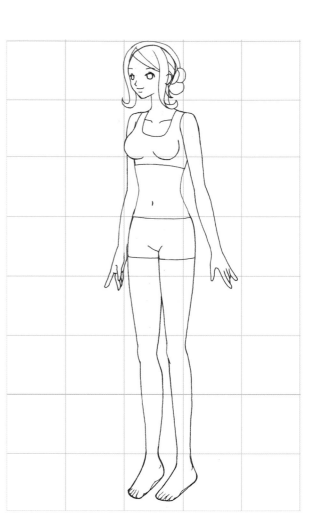

Refine the arms, and add eyes, a nose, and a mouth. For the ¾ view, the eye nearest the reader will look bigger. Draw toes.

Start drawing the hair, which should be bigger than the head. Draw a basic outline of the clothes. Refine the feet. Add collarbones.

Your woman needs a cute hat.

Draw the outline of the hat brim just above the eyebrows.

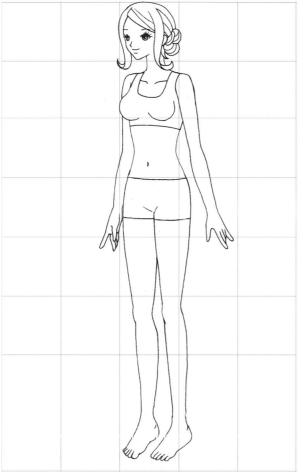

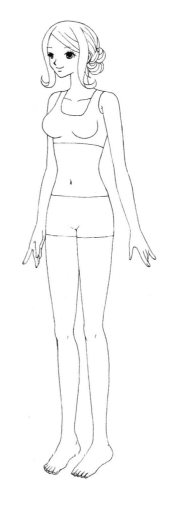

Add some details to the eyes and hair. Add some lines to the bun to show it is made from her hair.

Add a few small details to her hair.

The hat is much higher than her hair. Note where the band sits on top of the head.

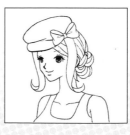

Add a bow at the side for a feminine touch.

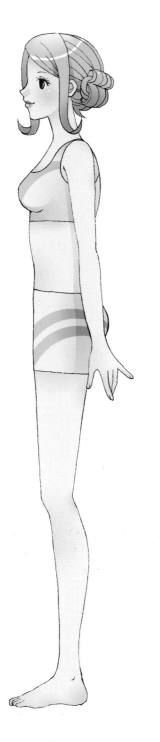

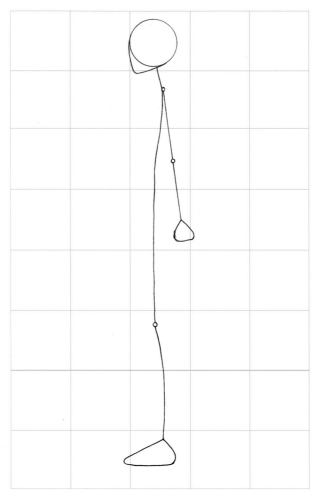

Draw a stick figure rotated for a side view. Draw circles where the joints are located.

Side View

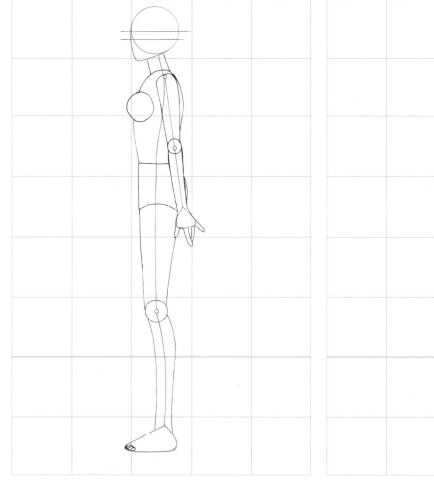

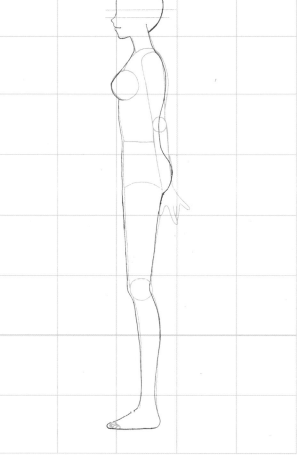

Draw a basic outline for the body, with guidelines for the eye placement. Add fingers and toes.

Refine the body, leg, and head shapes. The face should be longer than a teen girl's, so the nose is also longer.

From the side, a teen girl's body shape is not as curvy and has a shorter torso.

From the side, a woman's body shape is curvier and has a longer torso.

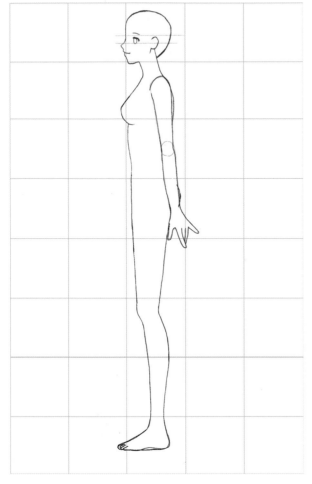

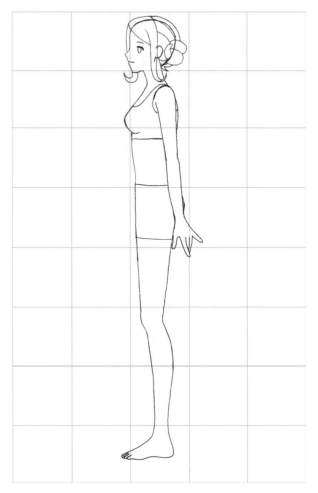

Refine the arms and face. Only one eye is visible. The ear should be fully visible. Refine the feet.

Start drawing the hair, which should be bigger than the head. Draw a basic outline of the clothes.

It's time to dress your woman.

Draw a long-sleeve sweater, close to the body.

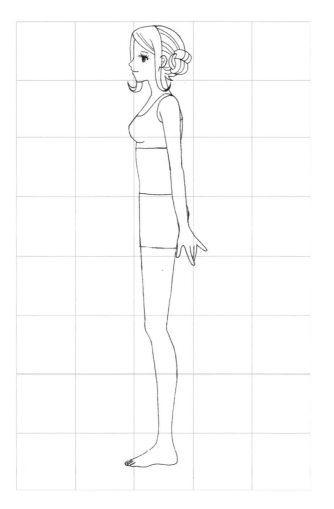

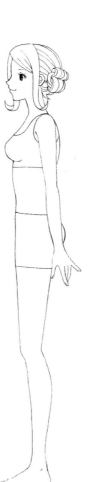

Add some details to the eyes and hair. Add some lines to the bun to show it is made from her hair.

Add a few small details to her hair.

Add a shawl collar and a short, straight skirt.

Here it is with the finishing touches.

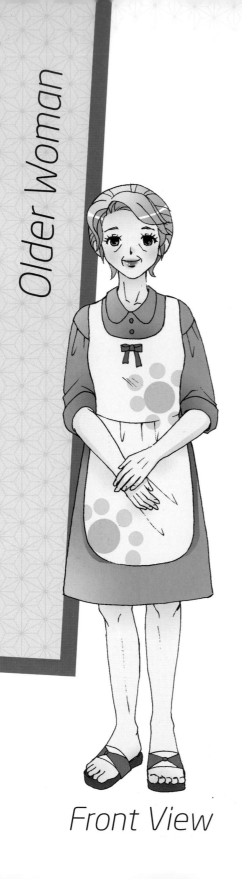

Draw a stick figure that's a bit shorter than an adult woman. There's a slight hump on the back, making the shoulders rounded. Draw circles where the joints are located.

Front View

Gravity takes its toll as the body ages: breasts droop, the waist thickens, hair greys, and skin wrinkles. Manga women should be beautiful even as they age.

Draw a basic outline for the body, with guidelines for the eye placement. Add two circles on her chest as a guide for drawing breasts; they should be smaller and sit lower than on a younger adult. Draw fingers.

Refine the body, leg, arm, and head shapes. Add ears. Remember the body should be thicker.

From the front, a young woman's body is very curvy.

From the front, the older woman's curves droop.

Add eyes, a nose, and a mouth. Draw toes. Start drawing the hair, which should be bigger than the head.

Draw a basic outline of the clothes. Refine the feet.

A cloche is a bell-shape hat.

The hat brim turns up.

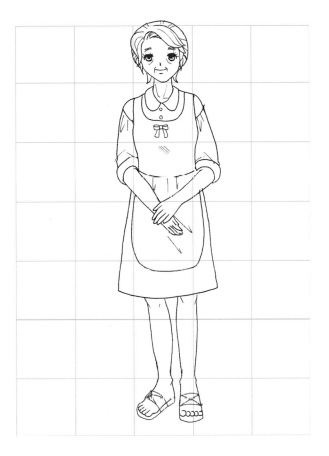

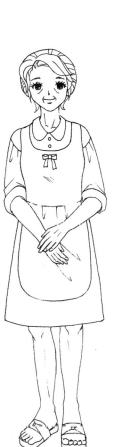

Add some details to the eyes, clothes, and hair. Add wrinkles to her face and neck. Draw sandals on her feet.

Add finishing touches, such as wrinkles to the hands and legs.

Here you see it more clearly.

Add some ribbon and a bow.

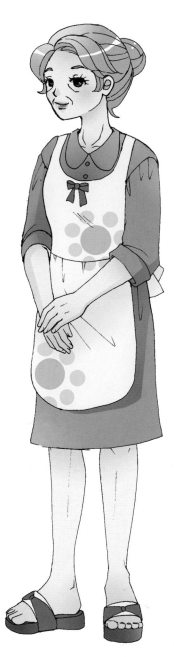

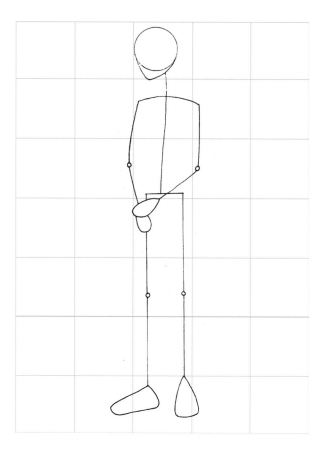

Draw a stick figure, rotated a bit toward the side. There's a slight hump on the back, making the shoulders rounded. Draw circles where the joints are located.

Three-Quarter View

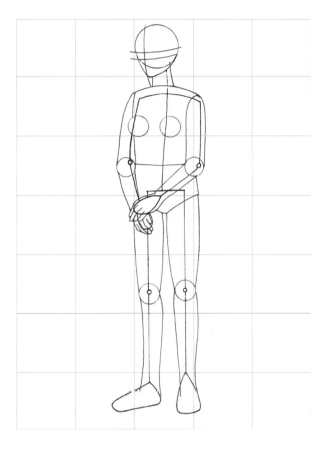

Draw a basic outline for the body, with guide-lines for the eye placement. Add two circles on her chest as a guide for drawing breasts; they should be smaller and sit lower than on a younger adult. Draw fingers.

Refine the body, leg, arm, and head shapes. Draw toes. Remember the body should be thicker.

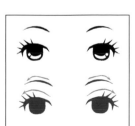

A young woman's eyes are wrinkle-free and curve up a bit at the corner.

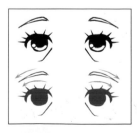

An older woman's eyes begin to droop.

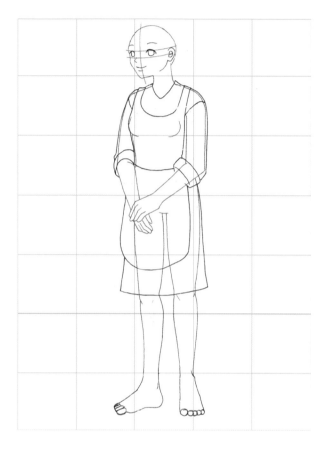

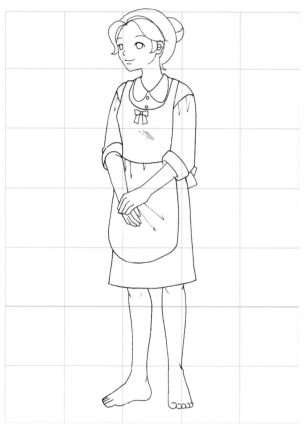

Add eyes, ears, a nose, and a mouth. For the ¾ view, the eye nearest the reader will look bigger. Draw a basic outline of the clothes. Refine the feet.

Start drawing the hair, which should be bigger than the head. Add some details to the clothes.

Your older lady might need a coat, too.

Draw the outline of a long coat.

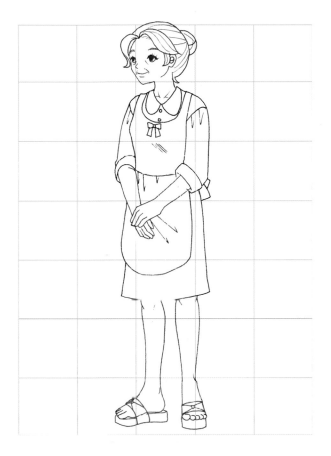

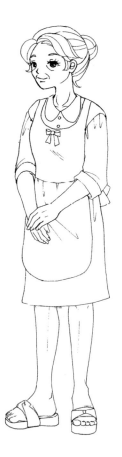

Add some details to the eyes and hair. Add wrinkles to her face and neck. Draw sandals on her feet.

Add finishing touches, such as wrinkles to the hands and legs.

Add a collar. Small strokes along the edge show it's fur. But don't worry—she wears faux fur!

Make the collar look like fur, and add a ribbon.

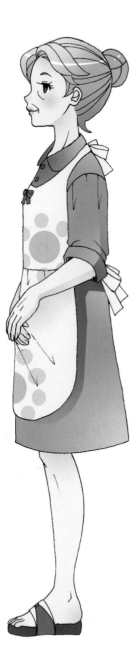

Draw a stick figure rotated for a side view. There's a slight hump on the back, making the shoulders rounded. Draw circles where the joints are located.

Side View

Draw a basic outline for the body, with guidelines for the eye placement. Add two circles on her chest as a guide for drawing breasts; they should be smaller and sit lower than on a younger adult. Draw fingers.

Refine the body, leg, arm, and face shapes. Add eye, ear, nose, and mouth. Draw toes. Remember the body should be thicker.

From the side, a young woman's body shape is very curvy.

From the side, an older woman's waist thickens, making her look more flat.

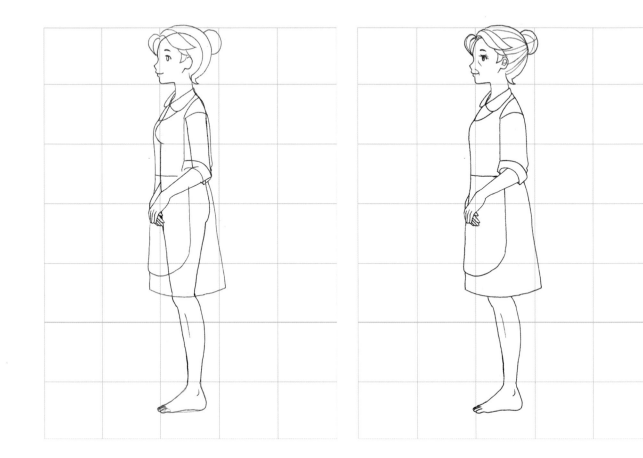

Start drawing the hair, which should be bigger than the head. Draw a basic outline of the clothes. Refine the feet.

Add some details to the eyes and hair. Add wrinkles to her face.

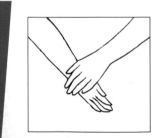

Start with a pair of crossed hands.

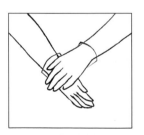

Lines at the wrist show where the gloves end.

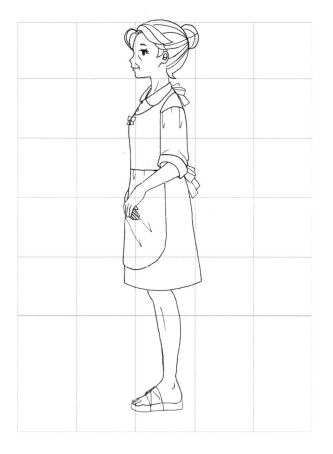

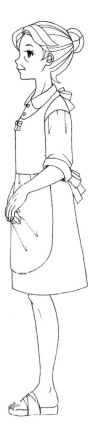

Add some details to the clothes, and draw sandals on her feet.

Add finishing touches, such as wrinkles to the hands and legs.

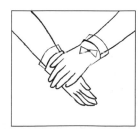

Another line makes a cuff. Add a bow.

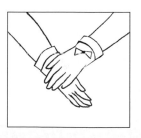

Now she has elegant gloves.

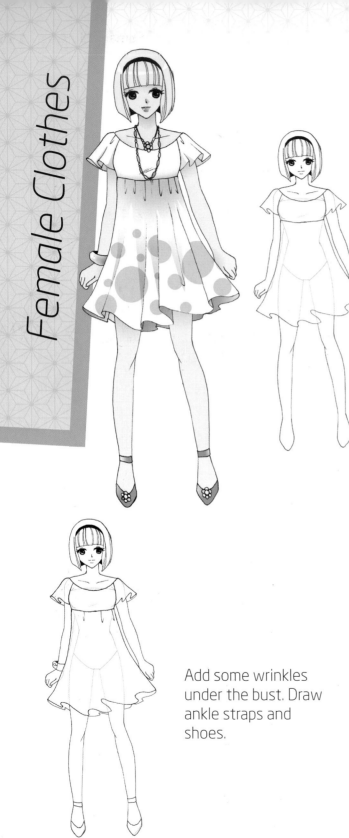

Party Dress

This girl is wearing a chiffon dress; this kind of fabric appears to float and has a light, slippery texture.

Start drawing the dress. Floating fabrics should be drawn with wavy lines along the hem.

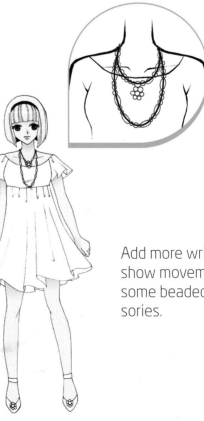

Add some wrinkles under the bust. Draw ankle straps and shoes.

Add more wrinkles to show movement. Add some beaded accessories.

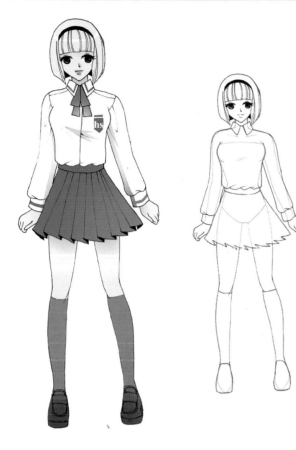

School Uniform

The uniform blouse is usually made from cotton, which has a light texture. The skirt is wool, which has a thick, heavy texture.

Draw the basic strokes around the body. For the skirt, draw neat, jagged strokes. Also draw lines for knee socks and shoes.

Add more wrinkles, stitching lines, and a bow-tie to the blouse.

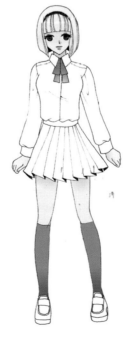

Draw the details of the shoes. Add shading to the edge of the skirt. Add lines to the skirt to form pleats.

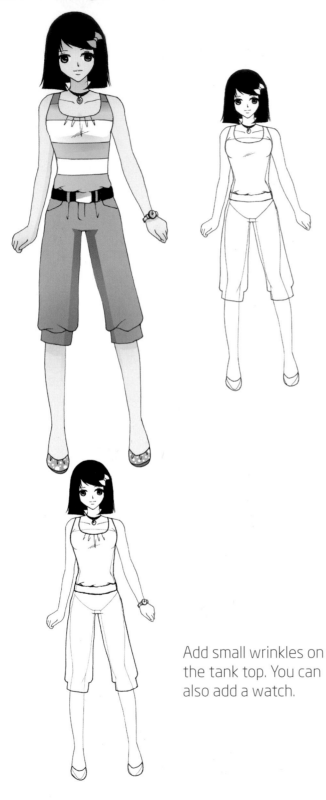

Casual Clothes

A tank top and cropped khakis with a pair of ballet flats is perfect for hanging out with friends after school.

Draw the basic lines for the tank top, capris, and shoes.

Add small wrinkles on the tank top. You can also add a watch.

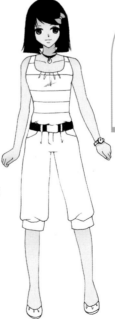

Add pockets to the capris, and refine the belt.

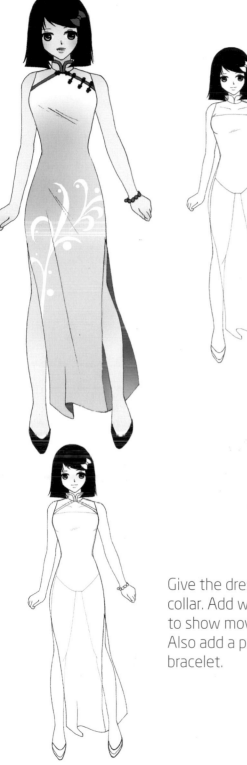

Shanghai Dress

The Shanghai dress is usually made from silk or other light fabrics. This elegant dress is suitable for a cocktail party.

Draw the basic lines for the dress and high heels. Be sure the dress flows.

Give the dress a collar. Add wrinkles to show movement. Also add a pearl bracelet.

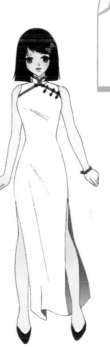

Refine the lines.

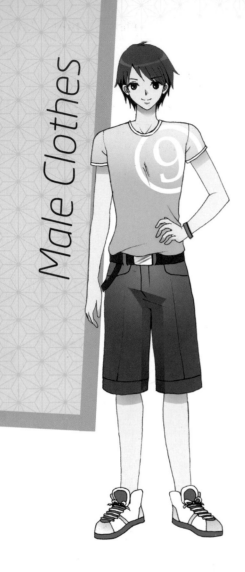

Casual

Boys' favorite clothes: a t-shirt and jeans. Don't forget the sneakers!

Draw the basic lines of the t-shirt, jeans, and shoes.

Add some folds on the jeans and details on the belt, shoes, and shirt.

Suit

Want your character to look more elegant? Give him a suit. Suits are usually made from stiff fabric, so they will have few wrinkles.

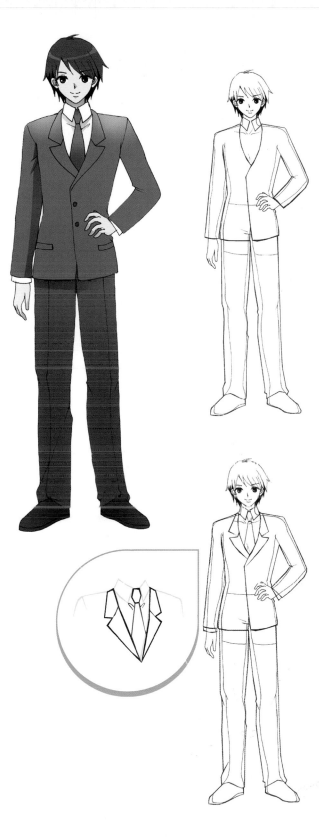

Draw basic lines for the suit, plus a shirt collar and shoes.

Draw the jacket collar and a necktie. Add a few wrinkles on the trousers and sleeves.

Add some details.

In Love

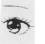 Raised eyebrows and
sparkling eyes

 Blushing cheeks

Shy smile

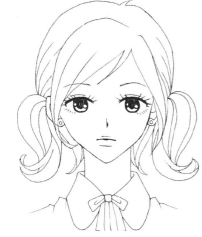

Begin with a calm, resting
expression for comparison.

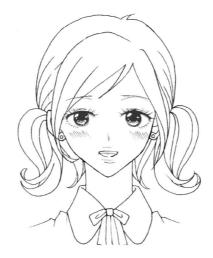

Draw the eyebrows higher
and give her sparkling eyes
and blushing cheeks. Draw a
shy smile, mouth upturned
and lips slightly parted.

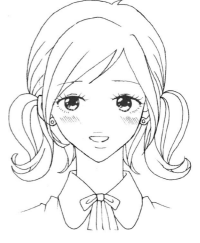

See the difference? Her ex-
pression is shy, hopeful, and
happy.

Sleepy

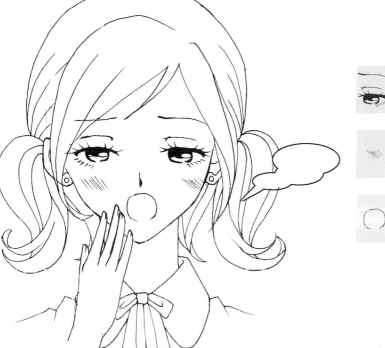

Eyebrows turned up slightly
Eyes slightly closed

Flushed cheeks

Yawning mouth

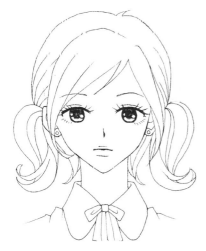

Begin with a calm, resting expression for comparison.

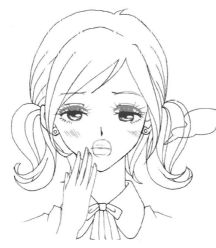

Draw the eyes half-closed so she looks tired. The eyebrows are turned up a bit. The cheeks are flushed. The mouth is open wide to yawn, and her hand comes up to cover it.

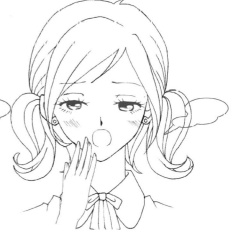

The sleepy girl has a little cloud from her mouth as a sign that she's yawning.

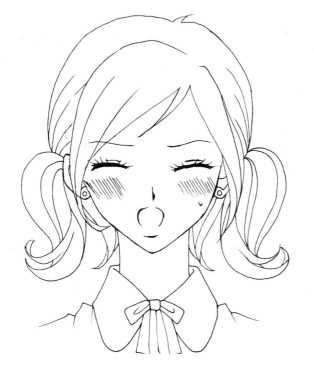

Embarrassed

 Eyes closed tightly

 Heavily blushed cheeks

 Mouth dropped open

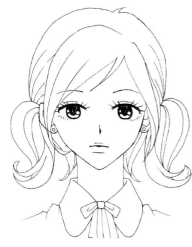

Begin with a calm, resting expression for comparison.

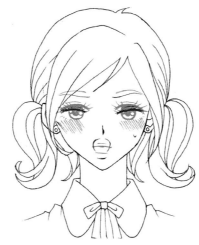

Draw the eyes closed tightly and a heavy blush on the cheeks. The eyebrows will lower. The mouth will drop open.

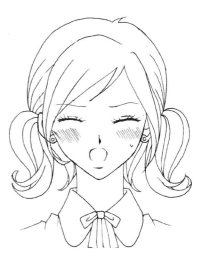

Note the small sweat drop on the cheek to show distress.

Shocked

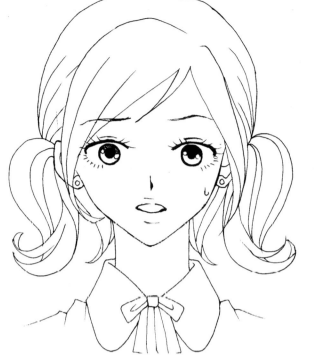

 Eyebrows wrinkled, eyes fully open

Mouth open, but speechless

A small sweat drop indicates distress

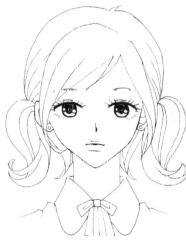

Begin with a calm, resting expression for comparison.

The eyebrows are wrinkled and eyes are wide open; draw the eyeball fully. The mouth opens as though she wants to say something, but is speechless.

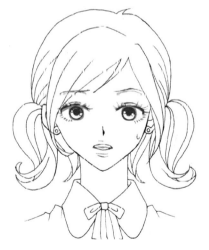

Note the small sweat drop on the cheek to show distress.

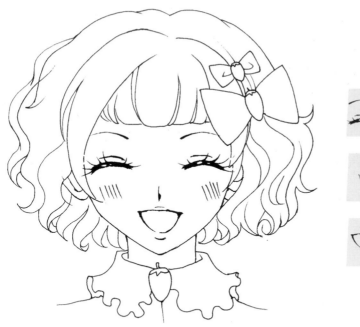

Happy

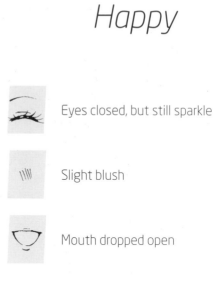

Eyes closed, but still sparkle

Slight blush

Mouth dropped open

Begin with a calm, resting expression for comparison.

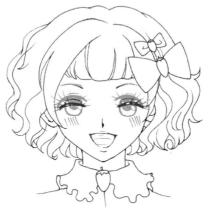

The eyes are closed, cheeks blushing a bit, and the mouth forms a wide smile.

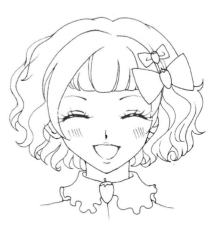

Even when closed, happy eyes will sparkle. Add some highlights to her closed eyes.

Sick

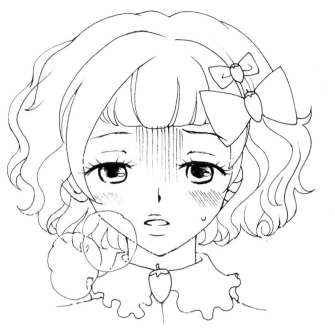

 Vertical lines on forehead to convey a sense of gloom

 Flushed cheeks, a drop of sweat indicate distress

Mouth turned down and slightly open

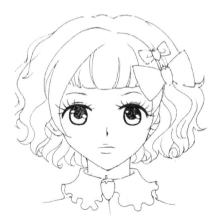

Begin with a calm, resting expression for comparison.

Draw half-closed eyes. Cheeks should be flushed; add a drop of sweat. The mouth should be open a bit.

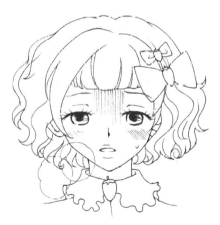

Vertical lines on the forehead are a common technique in manga; they convey a sense of gloom. Small clouds in front of the mouth show that she's breathing hard.

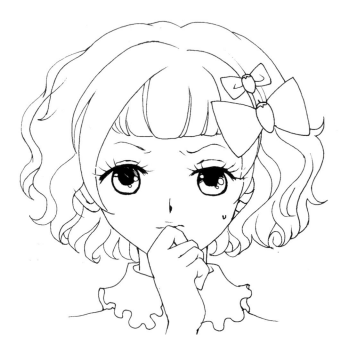

Thoughtful

 Eyebrow raised and curved, one eyebrow lowered

Mouth closed tightly

Hand drawn to mouth

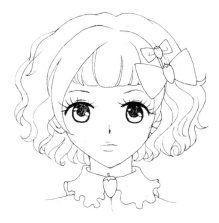

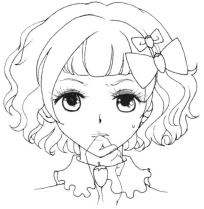

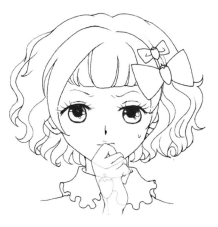

Begin with a calm, resting expression for comparison.

When she is thinking hard, the eyebrows will raise and curve. One eyebrow lowers, forming a small wrinkle on her forehead.

A small sweat drop shows effort. Draw her hand over her mouth, with the pointer finger raised.

Scared

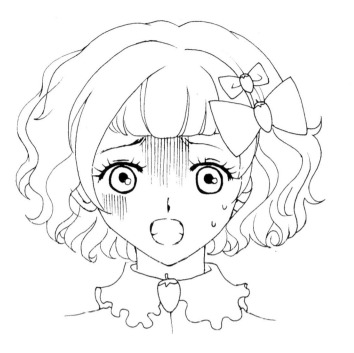

 Eyebrows raised in the middle of the forehead, turned down at the outside

 Eyes wide open, pupils smaller

Vertical lines on cheek and forehead to indicate sense of gloom

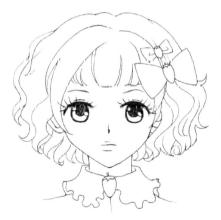

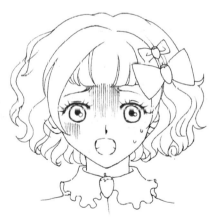

Begin with a calm, resting expression for comparison.

The eyes are wide open, and the pupils become smaller. The eyebrows should be turned down at the outside, and raised toward the middle of the forehead.

Add some vertical lines to the cheek and forehead, a common technique in manga for conveying a sense of gloom. Add sweat drops to emphasize her distress.

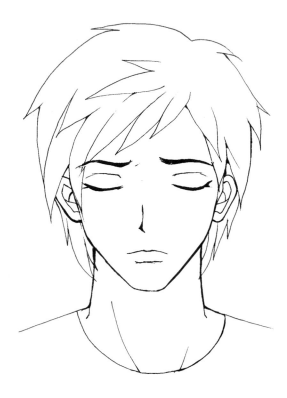

Sad

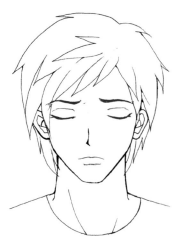

Eyes closed, eyebrows raised slightly in middle of forehead

Mouth closed tightly

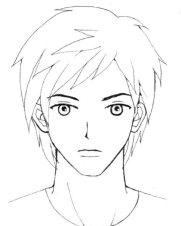

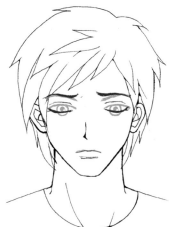

Begin with a calm, resting expression for comparison.

The eyebrows will raise toward the middle of the forehead. The closed eyes will curve down.

Note that the mouth curves down to show deep sadness. You can also draw the mouth curved slightly up to form a sad smile.

Angry

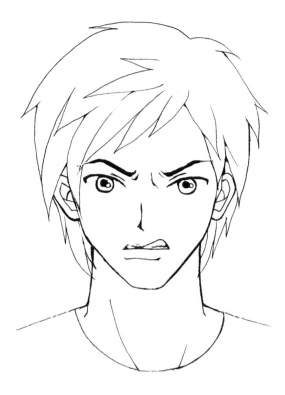

 Eyebrows lowered severely, wrinkling forehead

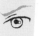 Smaller pupils

 Curled lip, baring teeth

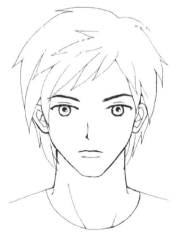

Begin with a calm, resting expression for comparison.

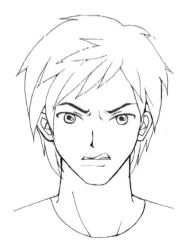

Draw the eyebrows lowered severely toward the nose, causing wrinkles. The pupils are smaller.

Note that the lip is curled, baring his teeth.

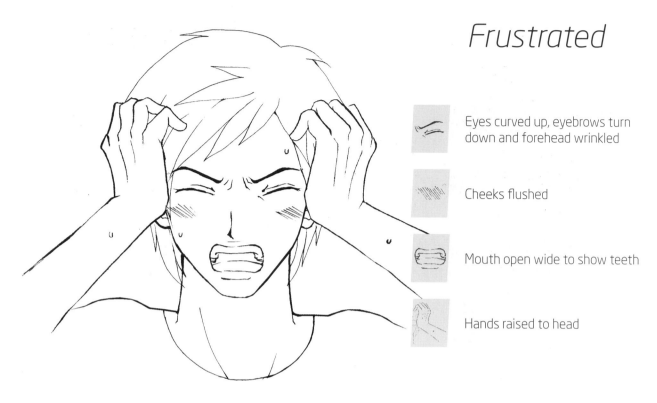

Frustrated

Eyes curved up, eyebrows turn down and forehead wrinkled

Cheeks flushed

Mouth open wide to show teeth

Hands raised to head

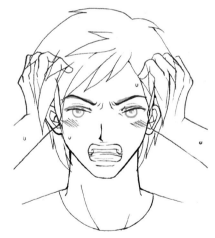

Begin with a calm, resting expression for comparison.

Draw the eyes curved up, combined with angry eyebrows and a wrinkled forehead. The cheeks should be flushed. Draw the mouth wide open to show almost all of his teeth.

Note the hands raised to hold his head; don't forget to raise his shoulder a bit, too. Sweat drops show distress.

Dissatisfied

Eyebrows turned down slightly

Eyelid lowered, pupil darkened

Mouth curved down

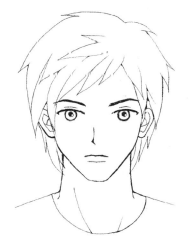

Begin with a calm, resting expression for comparison.

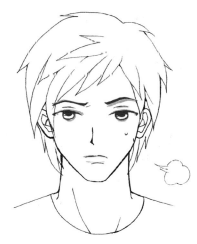

The eyebrows have a slight down turn. The eyelid is lowered a bit, and the pupil is darkened. The mouth curved down shows he isn't happy.

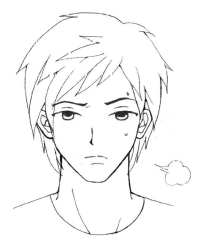

Add a sweat drop to show distress. The small cloud indicates a heavy sigh.

Standing Against a Wall

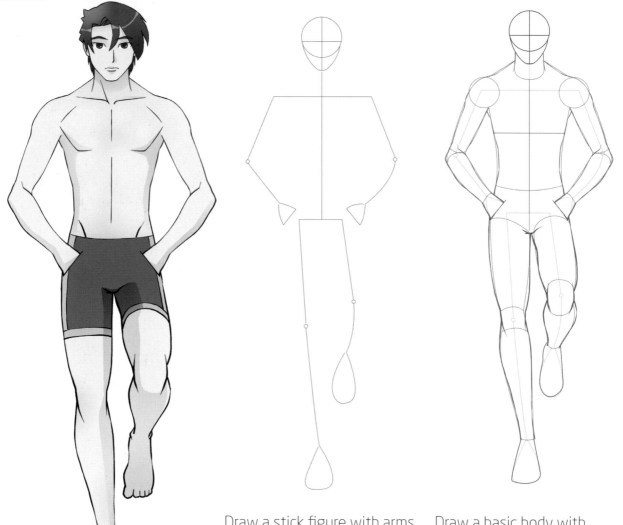

Front View

Draw a stick figure with arms bent as though the hands are in pockets. Lift one leg, bent at the knee to rest against a wall. The other leg should tilt a bit with the foot toward the center for balance.

Draw a basic body with muscles. The neck should be almost the same width as the head. The shoulders should be wider than the hips.

Notice how the leg resting against the wall is drawn shorter and the knee slightly wider than the other leg. This is a method of drawing perspective called **foreshortening**.

Draw the basic face and hair shapes. Draw basic feet.

Refine the facial features and feet. Add collarbones, and chest and stomach muscles. Add clothes.

Finish with details to the clothes.

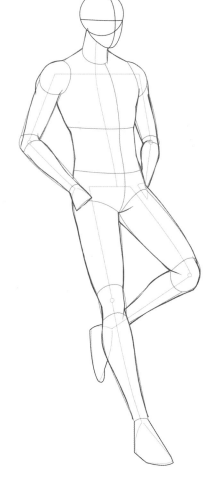

Three-Quarter View

Draw a stick figure with arms bent as though the hands are in pockets. From this view we can see one arm is bent more. Lift one leg, bent at the knee to rest against a wall. The other leg should tilt forward a bit for balance.

Draw a basic body with muscles. The neck should be almost the same width as the head. The shoulders should be wider than the hips.

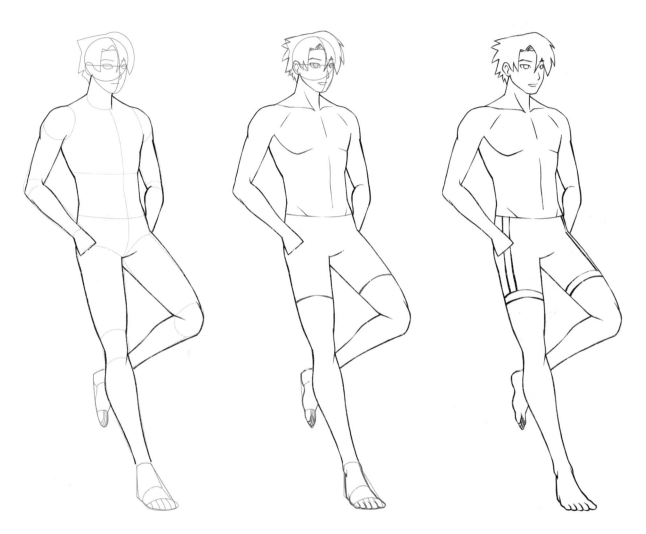

Draw the basic face and hair shapes. Draw basic feet.

Refine the facial features and feet. Add collarbones, and chest and stomach muscles. Add clothes.

Finish with details to the clothes.

Walking

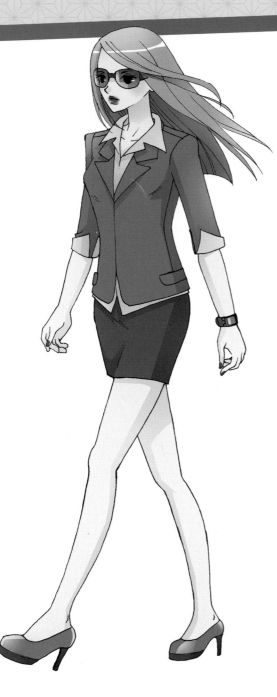

Draw a stick figure with the proportions of an adult woman. The legs should cross in an off-center X.

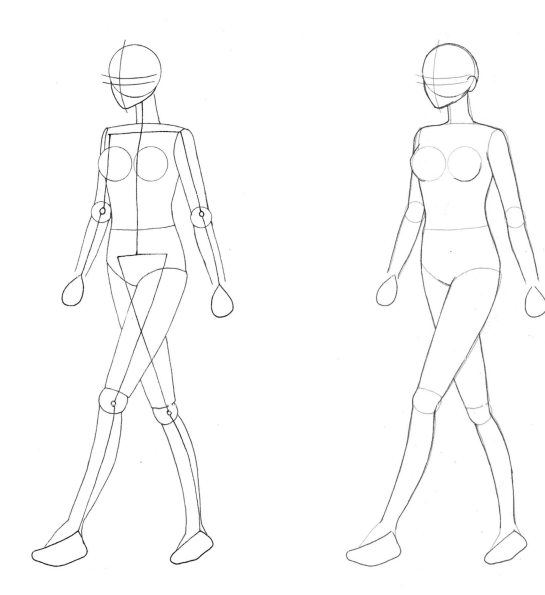

Draw a basic outline for the body, with guidelines for the eye placement. Add two circles on her chest as a guide for drawing breasts.

Refine the body, leg, arm, and face shapes. Draw ear.

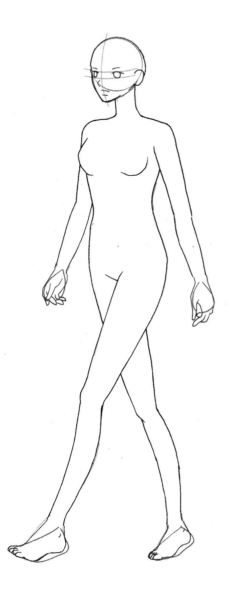

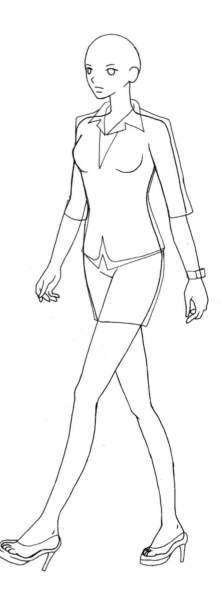

Add eyes, a nose, and a mouth. Start drawing the feet and hands.

Draw the basic outline of a business suit and high heels. Add a bracelet.

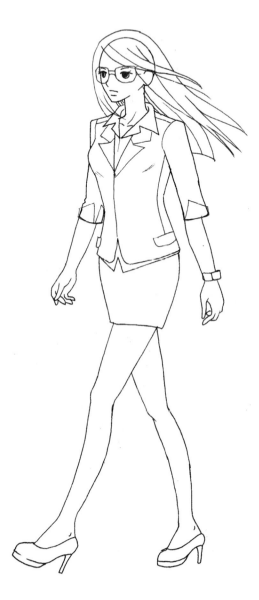

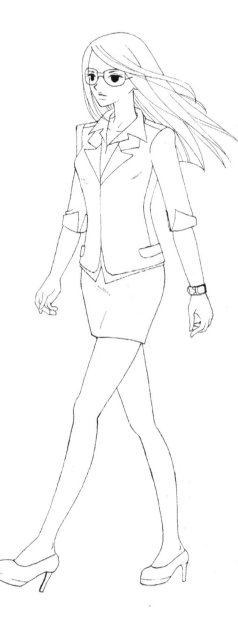

Start drawing long, straight hair; it should blow away from her face to show movement. Add details to the clothes and eyes, and draw glasses.

Add a few small details to her hair and clothes.

Running

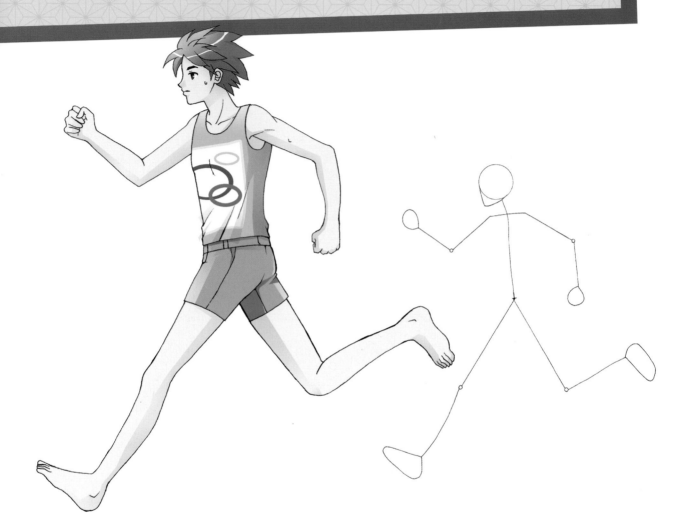

Draw a stick figure with the proportions of a teen boy. The figure should be rotated to the side, with legs spaced wide. Arms should be spaced to provide balance.

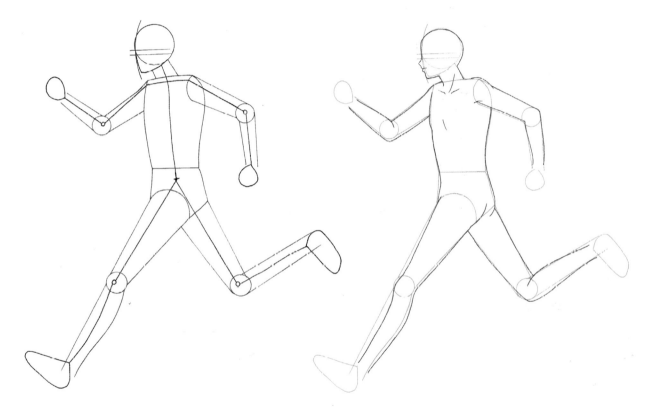

Draw a basic outline for the body, with guide-lines for the eye placement.

Refine the body, leg, arm, and face shapes.

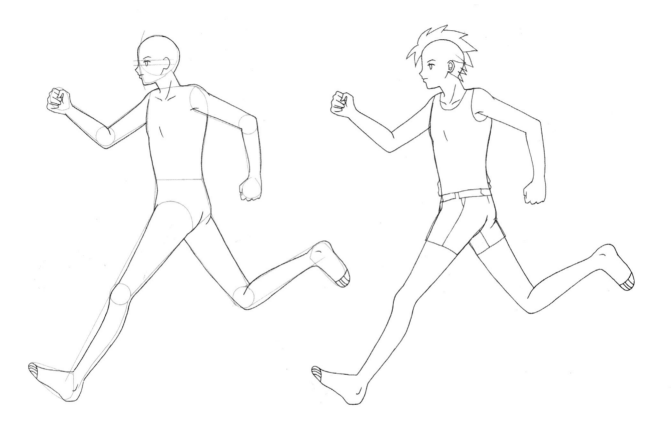

Draw basic eyes and ear. Draw the hands and begin drawing the feet.

Start drawing the hair, which should be bigger than the head. Draw a basic outline of the clothes.

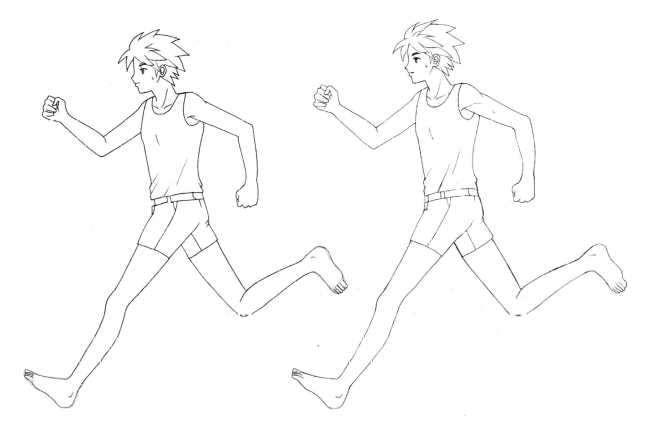

Add details to the eyes and hair. Add wrinkles to the shirt. Refine the feet.

Add a few small details to his clothes, hair, and arm.

Jumping

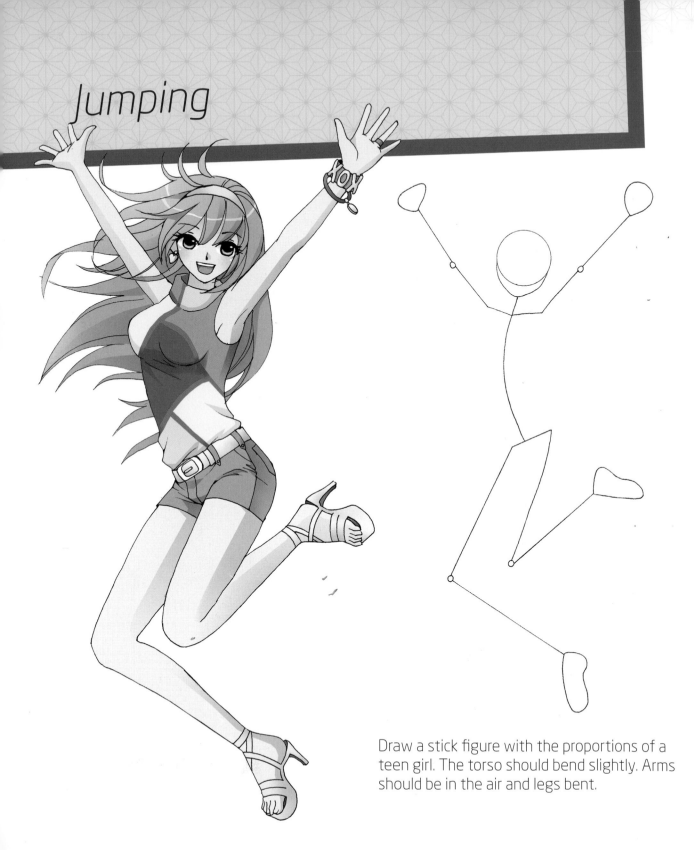

Draw a stick figure with the proportions of a teen girl. The torso should bend slightly. Arms should be in the air and legs bent.

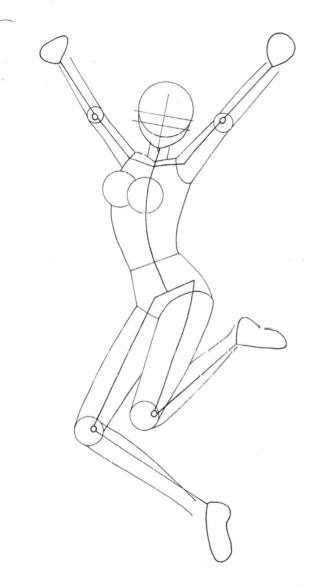

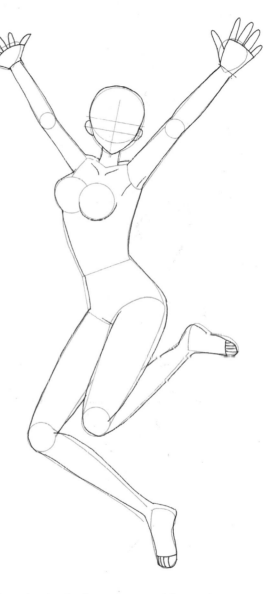

. Draw a basic outline for the body, with guide-lines for the eye placement. Add two circles on her chest as a guide for drawing breasts.

Refine the body, leg, arm, and face shapes. Draw ears. Begin the hands and feet.

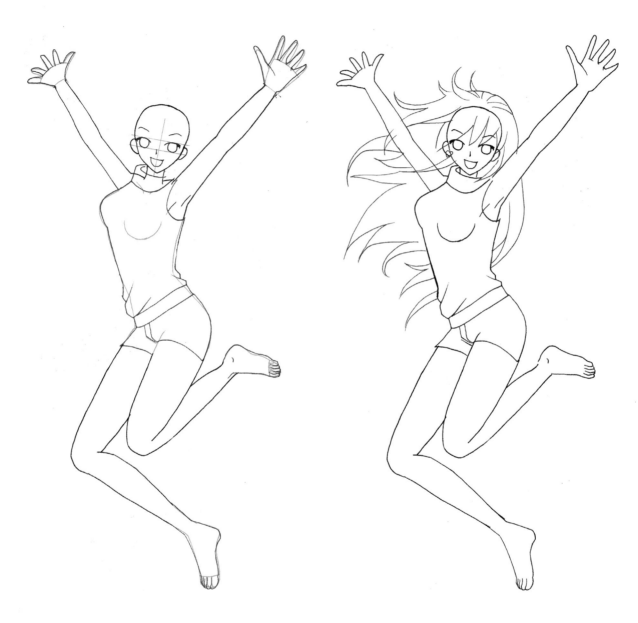

Add eyes, a nose, and a mouth. Draw a basic outline of her clothes. Refine the hands and feet.

Start drawing long, layered hair, which swings to the side to show movement.

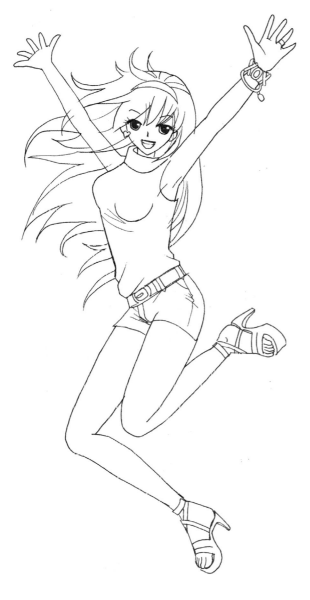

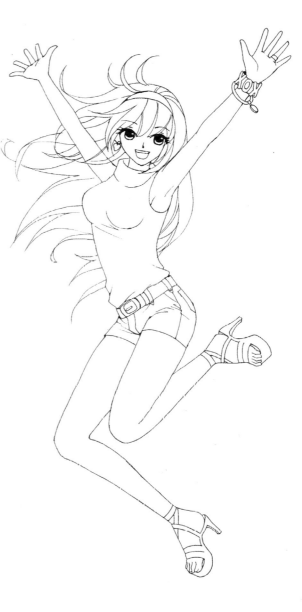

Add details to shorts, eyes, and hair. Draw high heels and bracelets. Add wrinkles to the shirt.

Add a few small details to her hair and clothes.

Sitting

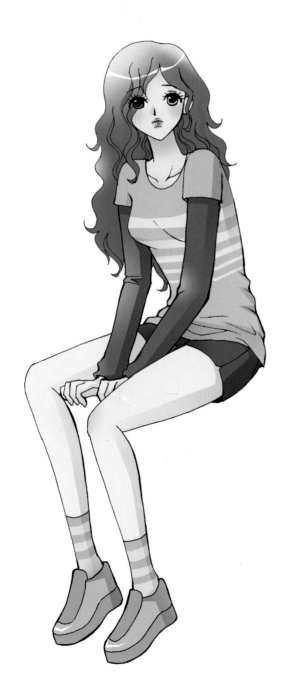

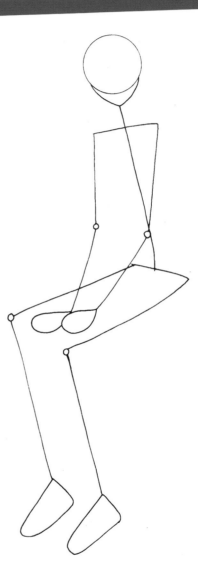

Draw a stick figure with the proportions of a teen girl. The arms are in front of her body, hands holding on to the chair she is sitting on.

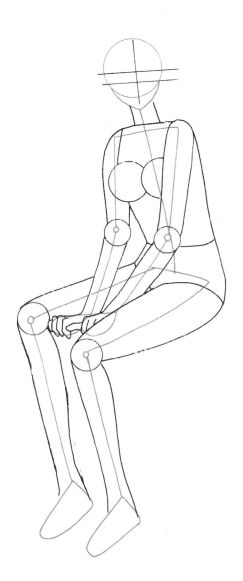

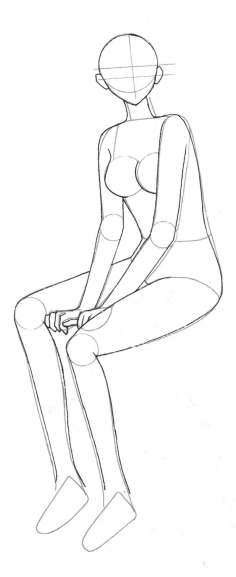

Draw a basic outline for the body, with guide-lines for the eye placement. Add two circles on her chest as a guide for drawing breasts. Draw fingers.

Refine the body, leg, arm, and face shapes. Draw ears.

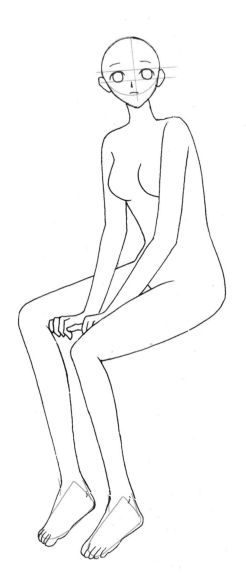

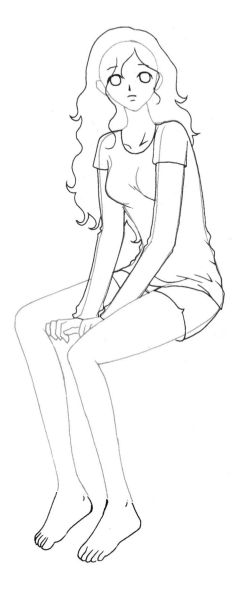

Add eyes, a nose, and a mouth. Start drawing the feet.

Start drawing long, wavy hair that falls in front of one eye. Draw a basic outline of her layered t-shirts and shorts.

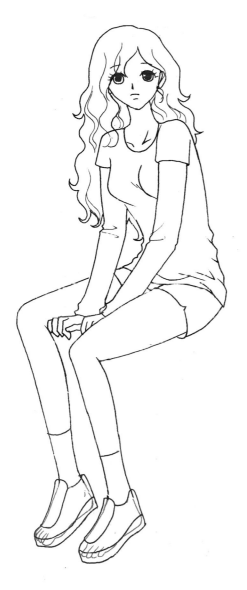

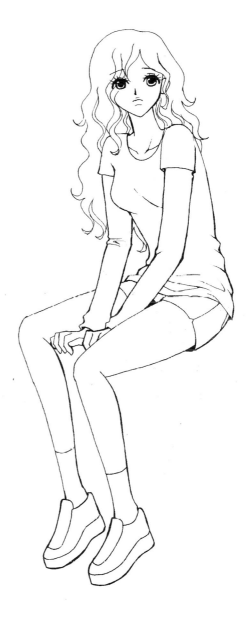

Add details to her eyes. Draw shoes and socks on her feet. Refine her hair by adding more wavy lines. Add wrinkles on her shirt, near the elbows.

Add a few small details to her hair and clothes.

Fight Stance

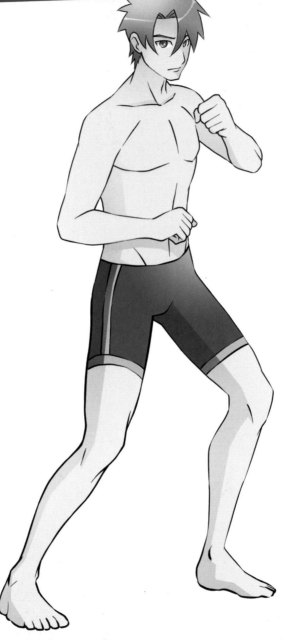

Front View

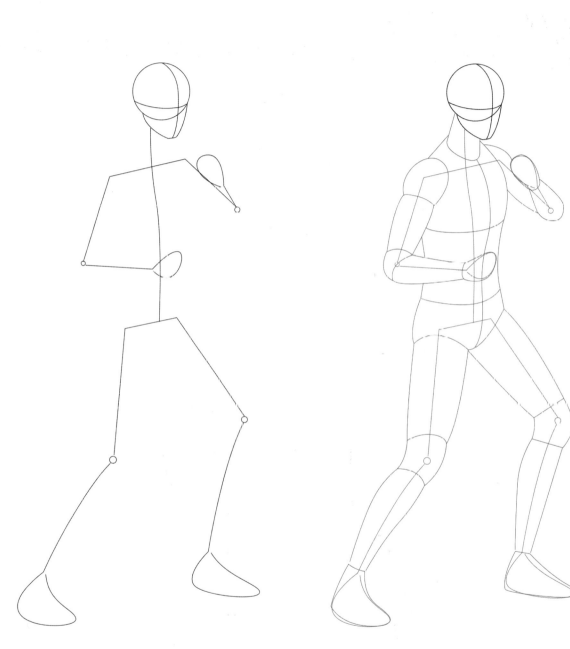

Draw a stick figure with legs open wide, as if he is ready to jump and attack. The arms are lifted up in a defensive position.

Draw a basic body with muscles. The neck should be almost the same width as the head. The shoulders should be wider than the hips.

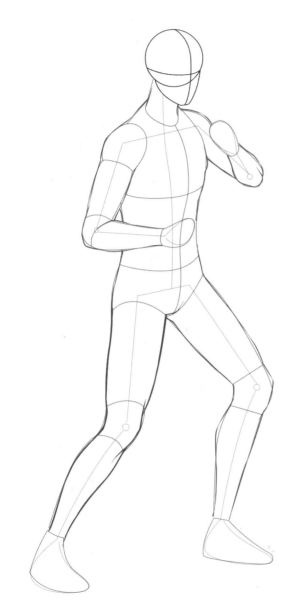

Refine the body, arms, and legs.

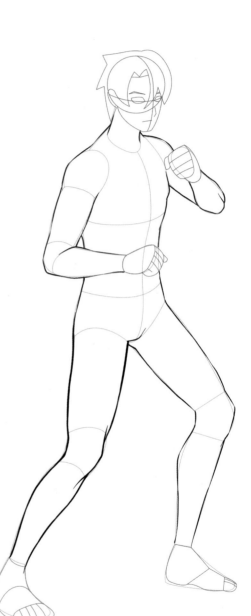

Draw the basic face and hair shapes. Draw basic hands and feet.

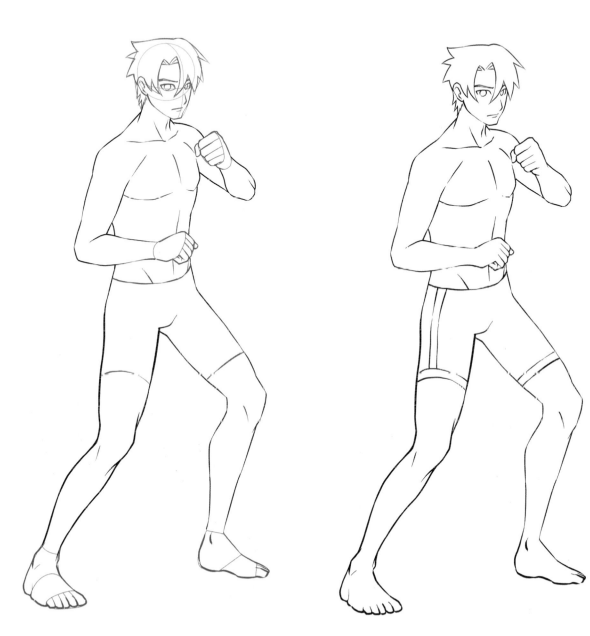

Refine the facial features, hands, and feet.
Add collarbones, and chest and stomach
muscles. Add clothes.

Finish with details to the clothes.

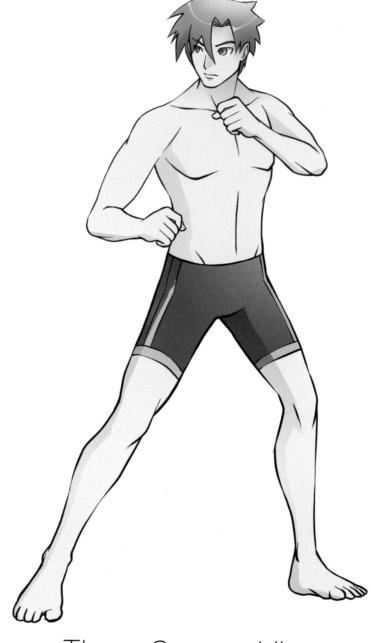

Three-Quarter View

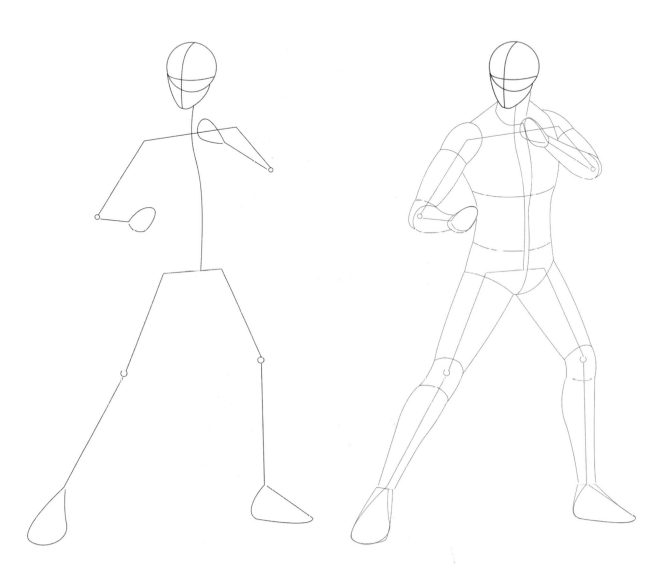

Draw a stick figure facing slightly to the right. The legs should bend forward, as if he is ready to jump and attack. The arms are lifted up in a defensive position.

Draw a basic body with muscles. The neck should be almost the same width as the head. The shoulders should be wider than the hips.

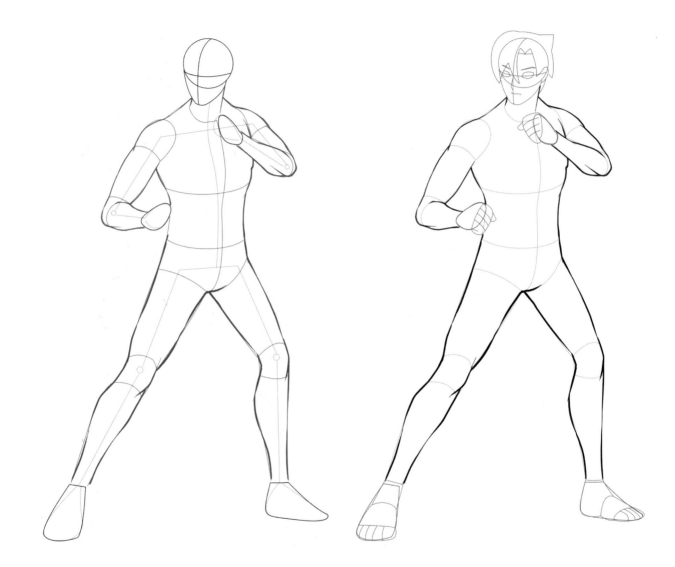

Refine the body, arms, and legs.

Draw the basic face and hair shapes. Draw basic hands and feet.

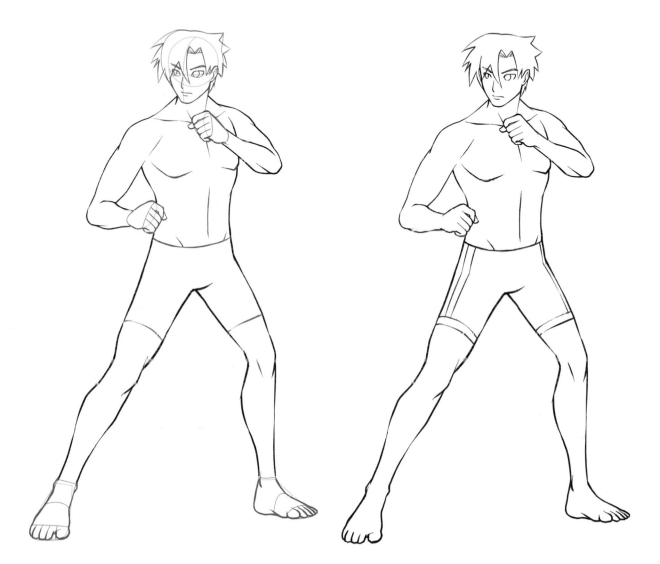

Refine the facial features, hands, and feet. Add collarbones, and chest and stomach muscles. Add clothes.

Finish with details to the clothes.

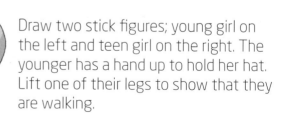

Draw two stick figures; young girl on the left and teen girl on the right. The younger has a hand up to hold her hat. Lift one of their legs to show that they are walking.

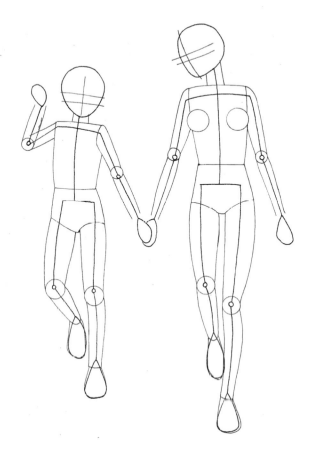

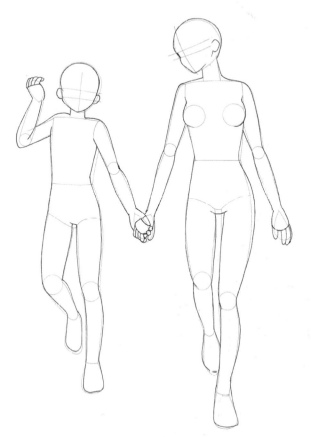

Draw a basic outline for the bodies, with guidelines for the eye placements. For the teen, add two circles on her chest as a guide for drawing breasts.

Refine the body, arm, leg, and face shapes. Add ears. Draw basic hands.

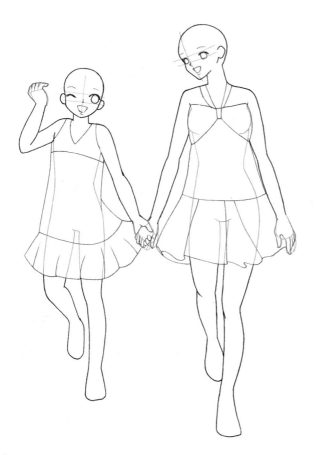

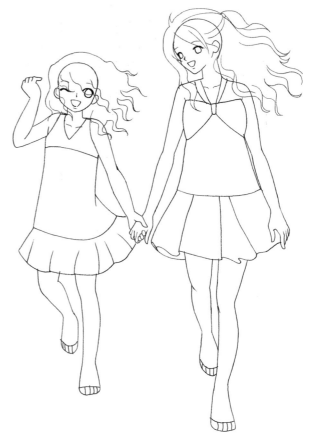

Add eyes, noses, and mouths. Note the young girl is winking. Refine the hands, paying close attention to their joined hands; fingers should be closely connected. Draw basic, flowing dresses.

Start drawing wavy hair on both girls; it should blow away from their faces to show movement. Draw toes.

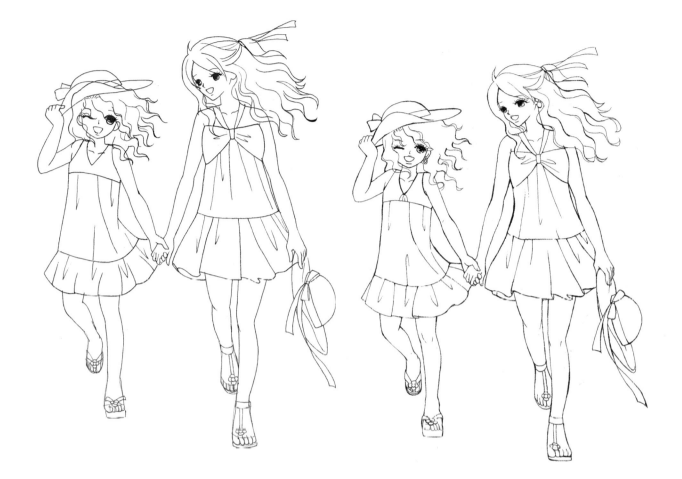

Draw details such as wrinkles on their dresses. Refine their feet. Draw hats. Add additional details to the hair, such as ribbons. Finish the eyes. Draw sandals.

Add finishing details to clothes and hair.

Draw two stick figures, both adult men. The man on the left has legs crossed as he steps toward his opponent, and an arm raised to strike. The man on the right has a wide stance for balance, and an arm up to block.

Draw a basic outline for the bodies, with guidelines for the eye placements. Add eyes, noses, and mouths.

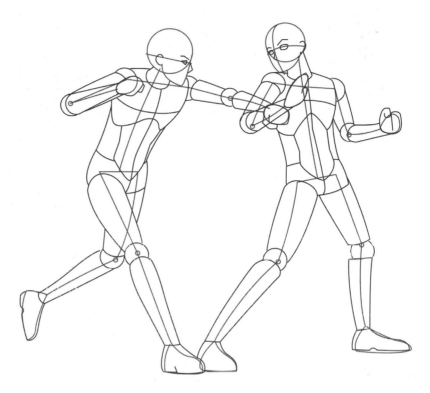

Refine the body, arm, leg, and head shapes. Add more detail to the faces. Draw hands.

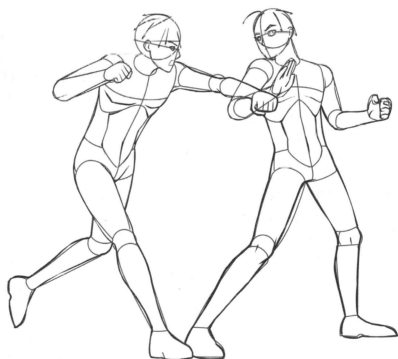

Start drawing the hair. Draw the basic outline of their clothes, including shoes. Refine the hands.

Pay attention to a character's musculature, even if he'll be wearing clothes. You'll get a more realistic finished product.

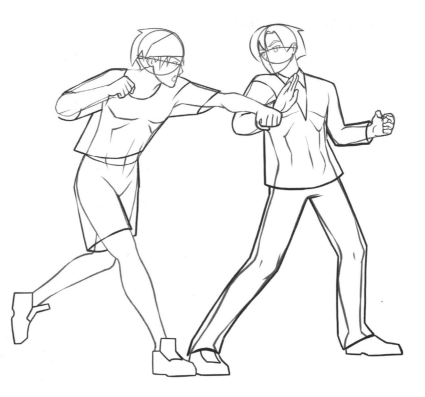

Refine the shape of the clothes, shoes, and hair. Note that the man on the left has a bandana and chain. The man on the right now has a tie and lapels on his jacket.

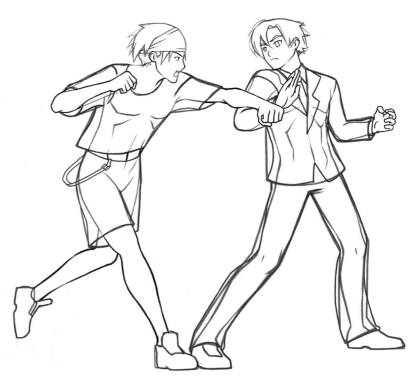

Draw wrinkles in the clothes.

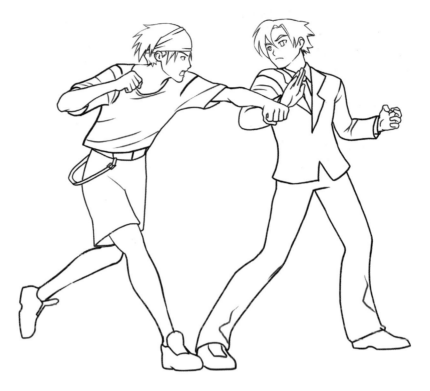

Add finishing details to their clothes and hair.

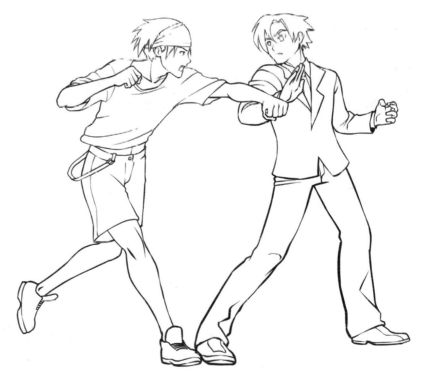

Draw two stick figures; young boy standing and young girl jumping with her arms around his neck. The boy's legs should be spread slightly for balance.

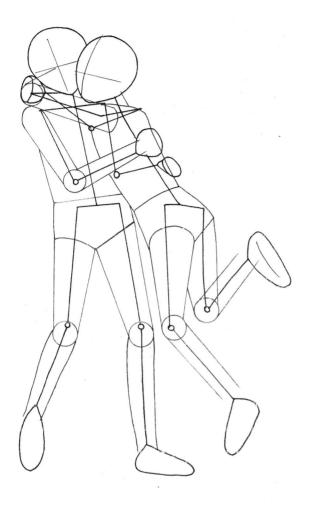

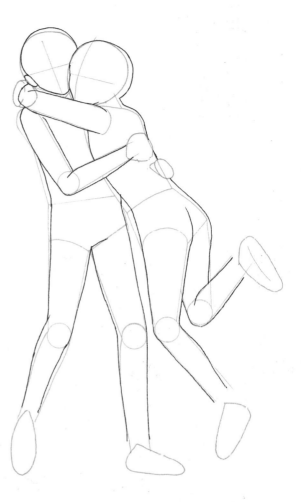

Draw a basic outline for the bodies, with guidelines for the eye placements.

Refine the body, arm, leg, and head shapes.

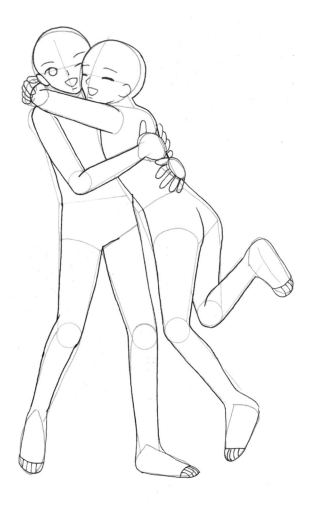

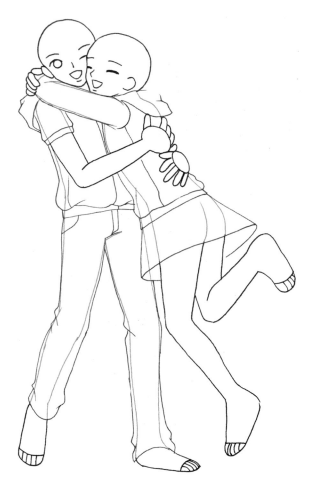

Add eyes, noses, and mouths. Note the boy has one eye closed, and both the girl's eyes are closed. Draw hands and feet.

Draw the basic outline of their clothes.

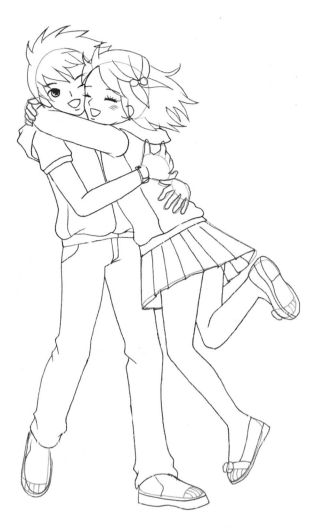

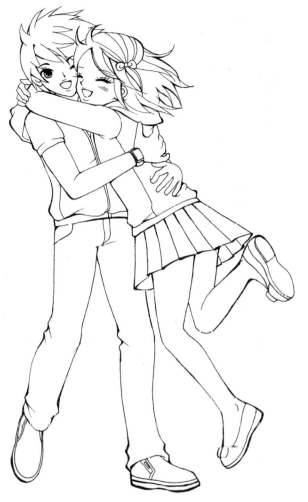

Draw the hair. Refine the hands. Finish their eyes, and add a blush to her cheeks. Give him a watch. Add pleats to her skirt. Draw shoes for both.

Add finishing details to their clothes and hair.

Draw two stick figures; a female and male adult. The woman's arms are wrapped around man's neck. The man holds her waist. The woman has one foot popped and is standing on her toes.

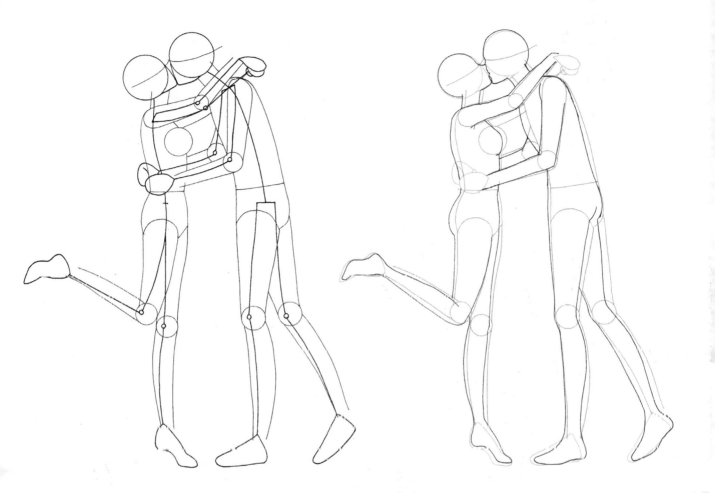

Draw a basic outline for the bodies, with guidelines for the eye placements. Draw circles where the joints are located. For the woman, add a circle on her chest as a guide for drawing the breast.

Refine the body, arm, leg, and head shapes.

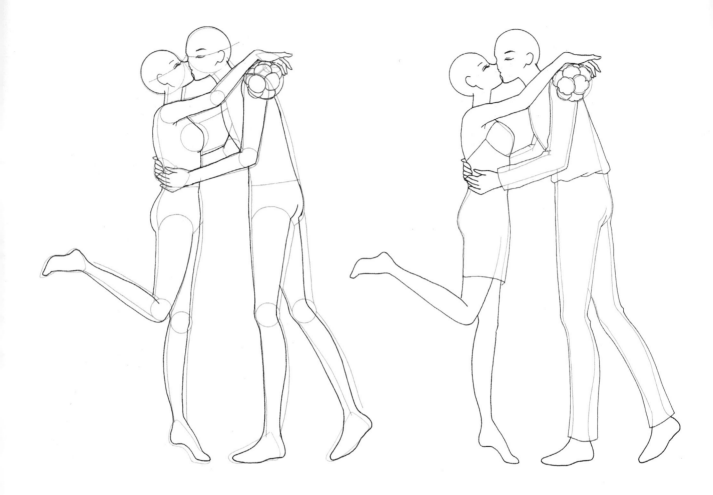

Add closed eyes to both figures. Draw their hands. The woman holds a bouquet of flowers.

Draw the basic outline of their clothes.

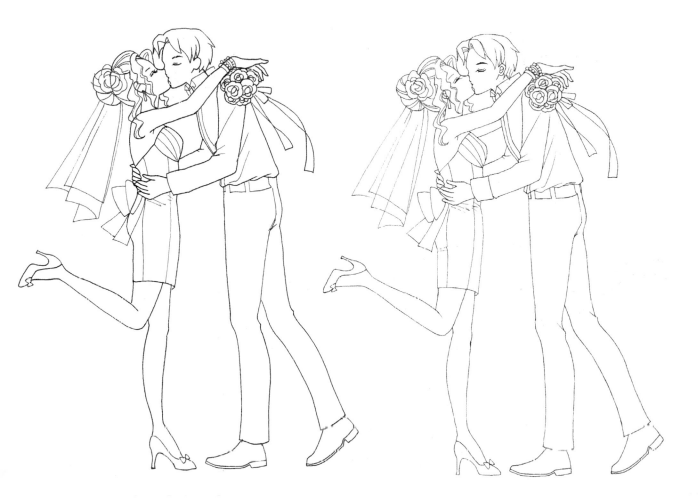

Draw hair and shoes for both figures. Don't forget to add details on the bouquet. Give her hair a big flower and a veil. Add seaming and a bow to her dress and bracelets on her wrist. Add wrinkles to his shirt and details to his trousers.

Add finishing details.

Draw two stick figures; a male and female adult. Her right hand is on his left shoulder. His left hand is around her waist. Their other hands are clasped.

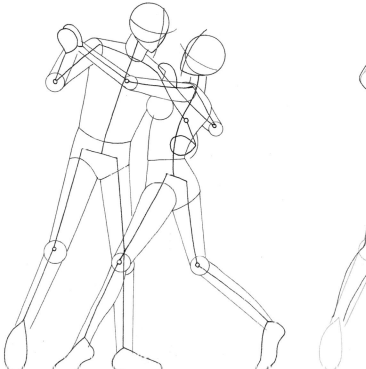

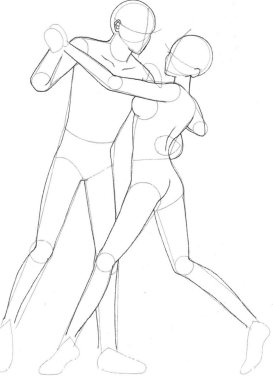

Draw a basic outline for the bodies, with guidelines for the eye placements. For the woman, add a circle on her chest as a guide for drawing the breast.

Refine the body, arm, leg, and head shapes. When one character leans forward, the other should lean back to keep their movement balanced.

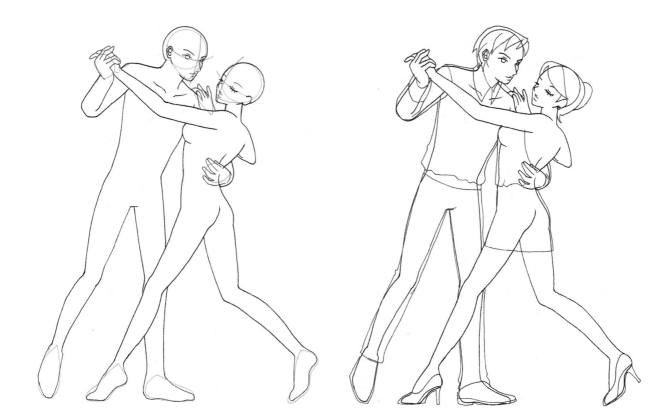

Add eyes, noses, and mouths. Note that her eyes are closed. Draw hands and feet.

At this stage, check the movement once again. If it seems unbalanced, do a quick revision.

Draw the basic outline of their clothes and shoes. Start drawing hair.

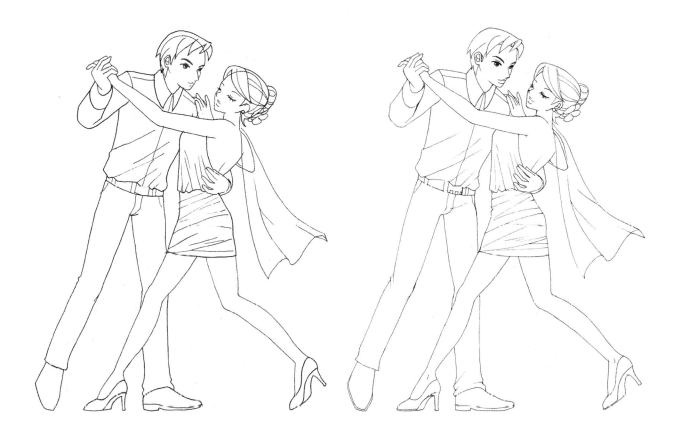

Refine the woman's hair and add a veil. Finish the man's eyes. Add wrinkles and other details to his clothes. Most of the lines on her dress are the fabric's texture, not wrinkles.

Add finishing details.